Victoria Crowe

Beyond Likeness

WITH AN ESSAY BY DUNCAN MACMILLAN AND
COMMENTARIES ON THE PORTRAITS BY VICTORIA CROWE

T0150704

NATIONAL GALLERIES OF SCOTLAND
EDINBURGH | 2018

Published by the Trustees of the National Galleries of Scotland
to accompany the exhibition *Victoria Crowe: Beyond Likeness*
from 12 May to 18 November 2018 at the Scottish National Portrait Gallery,
Edinburgh

ISBN 978 1 911 054 22 1

Designed and typeset in Arepo and ATF Garamond by Dalrymple
Printed in Belgium on Perigord 150gsm by Albe De Coker

Front and back cover: Victoria Crowe, *Mirror of the South (Self-portrait)*, 2001
[details of cat.42]

Frontispiece: Victoria Crowe, *Studio Venice: Mirrored View*, 2011 [detail of cat.47]

Inside back cover: Victoria Crowe, *Timothy O'Shea,* 2017 [detail of cat.51]

This exhibition has been made possible with the assistance of the Government
Indemnity Scheme provided by the Scottish Government.

The proceeds from the sale of this book go towards supporting the National
Galleries of Scotland. For a complete list of current publications, please write
to: NGS Publishing, Bridge Lodge, 70 Belford Rd, Edinburgh, EH4 3DE,
or visit our website: www.nationalgalleries.org

Directors' Foreword

This exhibition brings together a group of the finest portraits by the distinguished artist Victoria Crowe OBE FRSE RSA. Crowe has developed a highly individual approach to portraiture and our intention is not only to demonstrate the exceptional skill of a remarkable painter, but also to allow her to tell her story – both professional and personal – through her art. She has written:

> *The most important portraits to me are the ones of people who have enriched my own thinking or awareness. Areas of philosophy, religion, psychological perspectives, poetry, music, art history, women's roles and the inner life are key issues for me, and all have been nurtured by the people whom I have met through portraiture.*

Crowe had also spoken of the 'privilege' of painting a portrait and the relationship that develops between artist and sitter. Through her portraits, we in turn can also share something of the connection she has established with some very remarkable people.

We wish to extend our sincere thanks to all the important public and private lenders who have so generously enabled us to display these works together for the first time. The National Galleries of Scotland is particularly grateful to Walter and Norma Nimmo for supporting the exhibition and to The Scottish Gallery for its assistance. We would also like to thank Victoria Crowe's husband Michael Walton for his invaluable help and support, Duncan Macmillan for his contribution to this book and the staff of the National Galleries of Scotland that have worked on this project, in particular Julie Lawson the curator of the exhibition. Finally, and most importantly, we remain immensely grateful to Victoria Crowe, who has shared her insights and been such an inspiring collaborator throughout the creation of this important and celebratory project.

SIR JOHN LEIGHTON
Director-General, National Galleries of Scotland

CHRISTOPHER BAKER
Director, Scottish National Portrait Gallery

Introduction

The Scottish National Portrait Gallery has been the beneficiary of a long and fruitful association with Victoria Crowe. Although landscape and still life have constituted the greater part of her work as a painter, portraiture has played a significant role in her development as an artist. Her practice and her assiduous meditation upon it have developed continuously, taking the genre into new and at times unexpected directions.

The first portrait by Crowe to enter the collection was one of her paintings of the dream-therapist Winifred Rushforth. It was an important relationship for Crowe, introducing her to the theme of dreams – their interpretation, symbolism and structure – and to the work of Carl Jung. It is an interest that has informed her artistic practice and has been foundational for her picture-making.

Until the early 1980s, the Scottish National Portrait Gallery had limited its role to collecting. Then, the Director, Duncan Thomson, instigated commissioning. The collection no longer celebrated only the illustrious dead. Thomson's policy was to commission portraits from artists who were not exclusively or even primarily portrait painters, and Crowe was in the initial cohort of those he approached. The first commission she took up was to paint the psychiatrist R.D. Laing. Her study of his writings together with the intense engagement that the sittings entailed made another crucial contribution to her artistic and personal development. Like Rushforth, Laing was focused upon the psyche – the inner self: what makes us who we are. This concept of identity has fed into Crowe's approach to portraiture. Physical uniqueness is accompanied by metaphysical uniqueness. Crowe strives ever to give expression of what lies beneath the surface appearance: she seeks a 'spiritual' essence.

The Gallery next acquired the portrait of the composer Ronald Stevenson. Here, Crowe adopted the strategy of still-life amplification. It involved including an array of objects and artefacts referring to aspects of sitters' lives and things that were important to them; in effect, adding biography to likeness, so that the portrait becomes a record of time extended beyond the period of the sittings. There was more than the face to read. This innovation on the painter's part would later evolve into the aim to convey something of the inner workings of the sitter's mind through the inclusion of objects and imagery, serving more than the exemplary purposes of attributes, that were not necessarily physically present.

Artists often recount their experience of painting someone's portrait as the occasion of the development of a more intimate, closer relationship than would normally be possible with people who, by definition, are relative strangers. Crowe has frequently found friends in her sitters. The relationship between them could acquire an extra richness and complexity.

The time frame of a portrait can be significant. In 1995, Crowe was working on a portrait of Duncan Thomson (by then a family friend), when her son was diagnosed with terminal cancer. She has commented: 'Duncan looks very sad in that portrait … that's just how it was.' Victoria Crowe and her husband, Mike Walton, subsequently donated to the Gallery a portrait of the actor Graham Crowden, in memory of Ben Walton.

It was in 1997 that Crowe received an unusual commission: to paint a portrait of a Danish sitter. This emerged from a collaboration between the Scottish National Portrait Gallery and the Danish Museum of National History at Frederiksborg Castle in Copenhagen. A Scottish artist would paint a Dane, and a Dane a Scot. Crowe was selected to paint the great national hero Ole Lippmann, the leader of the Danish Resistance in the Second World War. This was to become another of the portraits that had particular significance for the artist. The painting, done in Denmark, stands out in her oeuvre; it is full of light – using a lighter palette perhaps than usual.

In her involvement with the Scottish National Portrait Gallery, a prominent episode took place in 2000, with the exhibition *A Shepherd's Life* consisting of work collected from the 1970s and 1980s. It could be described as an extended biographical portrait. Its subject was the shepherd Jenny Armstrong, a neighbour of Victoria and Mike in the Pentlands. Crowe made paintings of her over a number of years. The body of work formed a collective portrait of

this woman and her life and work – a celebration of an unremarkable but admirable life well lived, belonging within the most ancient traditions of the land and in kinship with the quiet heroism of those who have inhabited it.

We began the exhibition with a quote from Leon Battista Alberti – about portrait painting keeping friendship alive, the absent present and the dead living. This somehow seemed to encapsulate the very essence of Crowe's portraiture and its purpose.

In 2001, Victoria Crowe featured in the Gallery's exhibition *Narcissus: Twentieth-Century Self-portraits*. The self-portrait by Crowe that was borrowed for the show was called *Mirror of the South*.

It is worth quoting Crowe's analysis of this portrait for the insights it provides:

> *The painting is about contrasting states of mind and memories after spending the summer in Italy and returning to 'reality', work, and the clear light of the north. The visual preoccupations of Italy – the richness of gold, worn surfaces, the warmth, fragments of text, timeless images, myth and associations contrast with the almost palpable light and silence of a snow covered landscape at dusk. The unremarkable reality of the blackbird hopping about looking for food in the garden contrasts with the other reality of the Italian sojourn and all it represents to me.*
>
> *The reflected self-portrait is not the first thing that the viewer sees – but I wanted it to become an observer, the key player in both the realities set before you. My own reflection in the right hand panel is illuminated and affected by the candlelight, while remaining substantially part of the warmer mirror image …*
>
> *… Our sense of who we are is not so much what we physically look like, but about our perceptions of ourselves in the context of our life's events. Being in Italy that summer was to be reminded of all the other ways of being – the possibility of a new persona, the chance to ditch difficult issues – but then when one returns home, you just know that your life has to be about all of it and you accept the contrasts.*

Gradually, a new kind of painting had emerged: one in which memories, implied connections, symbolic forms are freely combined with objective external reality. A subsequent commission, to paint the composer Thea Musgrave, is an example of the new approach to portrait-making that Crowe had attained. The subconscious – the working of the creative process itself – has now become her subject matter. The portrait has emerged from a store, as Jung would say, of 'memories, dreams, reflections'.

JULIE LAWSON
Chief Curator, Scottish National Portrait Gallery

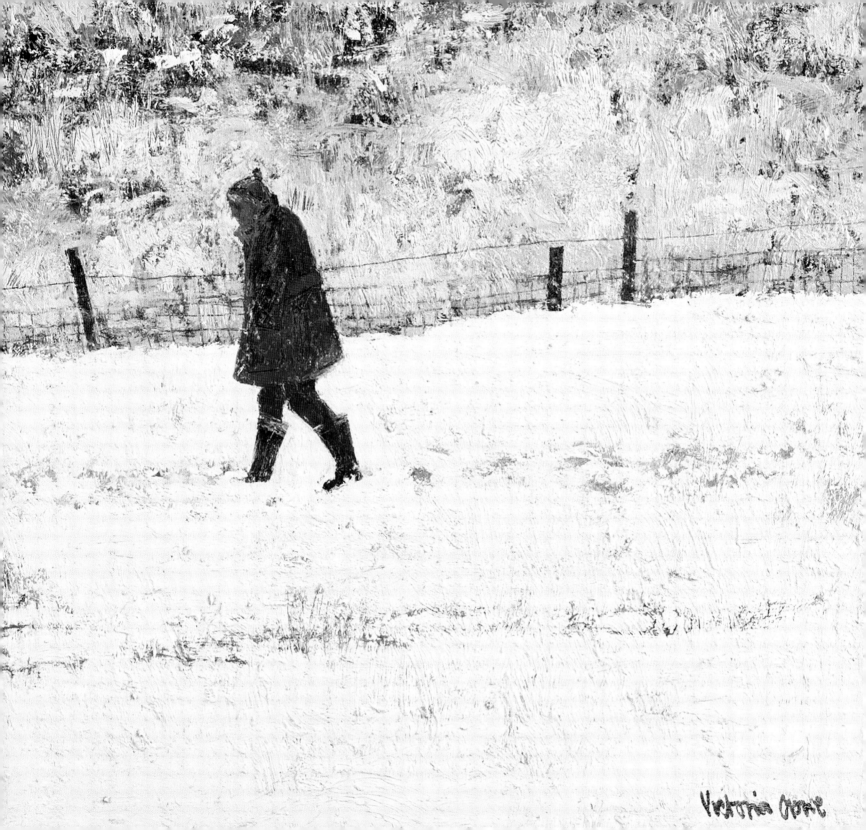

Victoria Crowe

VICTORIA CROWE: BEYOND LIKENESS

Duncan Macmillan

Portraiture is a social art. Consider, for instance, how Dr Johnson, who was not easily impressed, once said of his friend, the portrait painter Allan Ramsay, that 'he had the finest conversation in London'. It is surely no coincidence that Ramsay also painted some of the most luminously humane portraits of the eighteenth century. Sir Henry Raeburn too was a genial person, humorous, engaging and easy to talk to. He followed in Ramsay's footsteps, his work evolving towards a greater informality that vividly conveys a sense of the sitter's social presence. Without the enlivening humanity of this social exchange, the sitter simply becomes an object.

Certainly being painted by Victoria Crowe is a pleasant, relaxing and informal experience. Conversation is easy, but also something else happens. Perhaps it always does in this relationship, for it is odd being an object of someone's close scrutiny over a period of hours. Perhaps, too, you respond instinctively by wanting to affirm that you really are not simply an object. It is a little bit like being on the psychiatrist's couch. As the examination of your outer person proceeds, attention naturally progresses to some examination of your inner person. Sitting for Victoria, it may be her natural interest in people that brings this out, but the conversation does often seem to veer back to your own experiences, or the grounds on which your opinions are formed. This gift of sympathetic curiosity richly informs her portraits. I cannot comment on the success or otherwise of my own portrait, but there can be no doubt that, however she gathers the information and understanding that she deploys, it is the context or envelope that informs her portraits which sets them apart. Likeness is the key to any portrait, but more than any other contemporary, her work illustrates how painted portraiture at its best is a completely different thing from its photographic equivalent.

Victoria has painted a good many portraits, but she still does not regard herself as a portrait painter, and indeed her portraits have grown out of the wider concerns that informed her art from early on. They are part of it, not apart from it. In fact she has always painted portraits, but even now painting to commission is only occasional. More often a portrait is her own initiative. One of her earliest painted

portraits, too, her *Self-portrait with Icon* painted in 1964–65 when she was still a student [cat.1], is already much more than the record of her appearance. In the picture, the face of Christ, transcribed from an icon painted by Andrei Rublev, looms behind her far larger than her own image. Her once devout Catholic faith was leaving her, and this striking juxtaposition reflects her consequent spiritual crisis. She also makes her own likeness as flat and frontal as the icon's. Writing at the time in her student dissertation, she described how the icon painters were concerned exclusively with 'inner vision' and so not at all with the objective reality that had so long preoccupied western painters. So right at the beginning of her career, she is opening portraiture beyond likeness. Likeness is still there. A major part of her image, it identifies it, but in her portraits the wider, mental part is equally important.

During the 1970s when Victoria and her family were living in Monksview at Kittleyknowe near Carlops, just outside Edinburgh, she took this extension of portraiture far beyond the frame of a single picture into the whole sequence of paintings of the shepherd and her neighbour, Jenny Armstrong [cats 3, 4 and 5]. In 2000 these were brought together as though a single work in the exhibition *A Shepherd's Life* at the Scottish National Portrait Gallery. For all the formal differences, however, there was also continuity with the concerns reflected in her *Self-portrait with Icon*. The timelessness of the shepherd's life echoes the pastoral tradition in poetry, but also even more importantly the pastoral imagery that is everywhere in Christian belief and that inspired the very earliest Christian iconography, where Christ so often appears as the Good Shepherd and the Christian community as his sheep. Jenny Armstrong's fortitude and unstinting selflessness in her care for her flock in the face of stern hardship mirrored a life of spiritual dedication. It underlines this austerity that many of the paintings in the sequence were painted in winter. Kittleyknowe is high up. Snow was frequent, and the key images in the sequence are snowy landscapes of Jenny on her own or with her sheep and her dogs.

Victoria painted Jenny following her calling. She painted the landscape that she knew so intimately, but she also made a good many studies of the interior of Jenny's cottage, for where she lived

and what she surrounded herself with were all as much part of her persona as her relentless hard work. Victoria painted the ornaments on her mantelpiece, the glow of her fire, the clutter in her kitchen, or the light coming in through a shaded window. The warmth and closeness she records are contrasted to the world outside in which Jenny worked, and sometimes the one is visible from the other. She painted Jenny herself at home and moving around her cottage. She also painted two direct portraits of her, one in watercolour [cat.4], the other in oil [cat.5]. In the watercolour she is seated pensively in her armchair. In the oil painting, the last portrait of Jenny, she is in the wheelchair which she needed in the final years of her life. In both pictures the light is low but warm. Her environment fits her like a suit of comfortable clothes, an extension of herself. In the oil painting we see her from behind. The watercolour is frontal but her gaze is directed past the artist. She seems not actually to be looking at anything, but, reflective, her thoughts are turned inwards.

As an extended portrait, *A Shepherd's Life* stands on its own. Simpler portraits were however rare from these years. Victoria painted her husband, Michael Walton [cat.2], and her children [cats 27 and 40]. She did not really follow up the implications for more conventional portraiture of her approach in her early *Self-portrait with Icon*, however, till she painted the pictures that launched her as a portrait painter. These were the two portraits that she did of Winifred Rushforth in 1981–82 [cats 6 and 7]. Both ended up in public collections, one in the Edinburgh City Art Centre and the other in the Scottish National Portrait Gallery, but neither was painted to commission. Instead, characteristically they arose directly from a personal experience. Rushforth was one of the first women to graduate in medicine from Edinburgh University. Later she moved to psychology, but took an increasingly individual approach to the subject. Victoria and her husband met her after buying a small drawing by Wilhelmina Barns-Graham which it transpired had come from Rushforth's collection. They were invited to her ninety-fourth birthday party. Thereafter they established a friendship and were invited to join Rushforth's weekly 'dream' groups. The troubled ghost of Victoria's lost faith had never

been entirely laid to rest, and so Rushforth's approach to spirituality and the subconscious appealed to her.

Rushforth was interested in Carl Jung, with whom she had corresponded. His ideas informed these discussions and in turn they are reflected in the portraits that Victoria painted of her. In the smaller of the two [cat.7], her face partly in shadow, but with strong light from a window behind her, she seems to hover at the edge of the darkness that opens to the right of the picture and indeed to turn towards it. Perhaps unconsciously the artist has seen her at life's threshold, for she died the following year, but her conscious intention seems rather to have been to suggest how much she could be a guide into our inner darkness. It is like the opening image in William Blake's illuminated poem *Jerusalem*, the poet carrying a lamp as he steps into a dark doorway to illuminate what lies unseen within. Ramsay too painted his friend the philosopher David Hume on the edge of darkness, suggesting both the sitter's recognition of that darkness and his power to illuminate it.

The other figure in Victoria's painting is a carved wooden statue of a Bushman by the contemporary sculptor Christopher Hall which stood in Rushforth's study. It is seen against the light, head thrown back as though crying out in some kind of existential angst. Bushmen can seem like living witnesses to the primeval condition of humanity, to Jung's idea of the depth of the shared experience of countless generations that has formed our collective unconscious.

The same Bushman figure stands to one side in the other Rushforth portrait [cat.6]. Rushforth herself is centre stage, but still partly in shadow and against the light from the window behind her. The drawing for the picture was done in her house in Lauder Road, Edinburgh, and so the window is in her own home, but astonishingly, instead of onto a garden, it seems to open onto a scene of dinosaurs roaming in the primeval swamp from which the first mammals, our ancestors, emerged. We forget that enormous continuity, but who knows what dim traces from that remotest time lie buried in the deepest substrata of our subconscious? In both of these pictures, however, the stark imagery that reflects such speculations is also

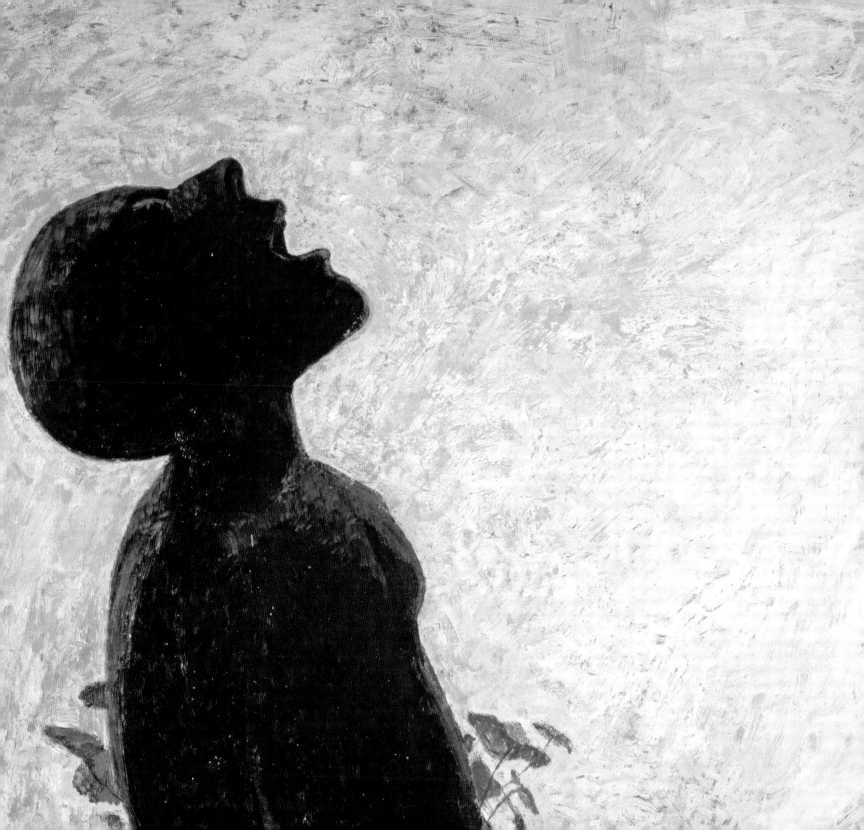

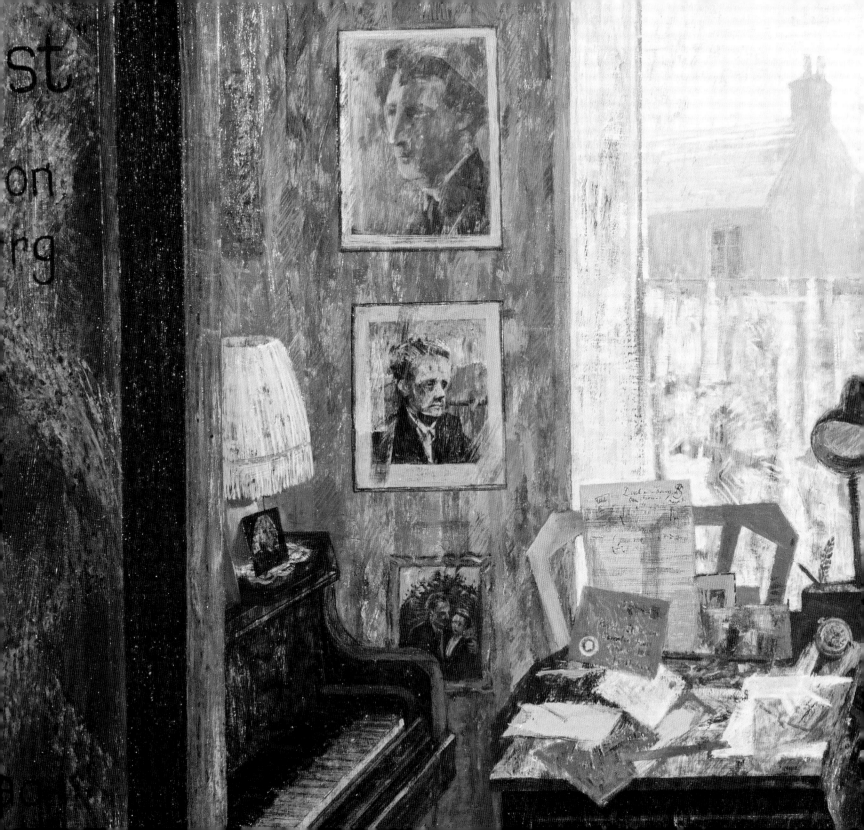

softened by the presence of houseplants, nature tamed and brought indoors. It recalls Hume again. Staring into the philosophical abyss, he tells us in his *Treatise of Human Nature* how he is comforted by the knowledge that he can leave his study and return to his friends and to normality. 'I dine, I play a game of backgammon, I converse, and am merry with my friends. And when, after three or four hours' amusement, I would return to these speculations, they appear so cold, and strained, and ridiculous, that I cannot find in my heart to enter into them any farther.'

Victoria's renewed interest in portraiture that produced the two paintings of Rushforth was then continued in a series of pictures of friends, or of people who interested her. She painted a portrait of Patrick Bourne, a friend just embarking on what has evolved into a distinguished career as a dealer [cat.12]. She also painted Marion Pulford, a friend of her mother's in Carlops [cat.8]. It was Marion Pulford's face that interested her, and it is a rather edgy portrait, reflecting perhaps the sitter's slightly fragile mental state. A few years later she also painted a head of Duncan Thomson, Director of the Scottish National Portrait Gallery [cat.31]. Several of the portraits which Victoria painted at this time out of interest in the sitters also ended up in public collections, including the Scottish National Portrait Gallery. This happened for instance with the portrait of the musician and composer Ronald Stevenson [cat.11].

Stevenson was living in West Linton and was teaching the artist's son, Ben, the piano – not just scales and exercises, she remembers, but true musicality – and Ben loved it. Stevenson is in his study, and the way she uses this, his working environment, is similar in intention to the way in which she painted Jenny Armstrong, though compressed into a single image rather than extended over several. Three-quarter length, he is standing looking reflectively past us. Here again he is seen *contre-jour*, against the light, with a window behind him. It is a position which Victoria likes to use because it reinforces the unity of the picture. It integrates the sitter with his or her environment, she says. If they were lit more directly, the sitters would stand out from the context in which she has set them. However carefully described, the things

with which they surround themselves would merely be background. Here, the sitter's face is only slightly in shadow, however, and his eyes and firm gaze are clearly visible. His cluttered desk is behind him in the window and there is a piano on the left-hand wall, half-hidden by an open door. There are portraits of the poet Hugh MacDiarmid, and the composers Percy Grainger and Ferruccio Busoni, on the wall and a poster for a production of the opera *Faust* on the back of the door. The word 'Faust' is only partly legible, but nevertheless conjures the image of Faust in his study. The subject of a celebrated lithograph by Eugène Delacroix, consciously or otherwise, here it suggests the sitter's access to the mysteries of music. Propped on a music-stand desk is the manuscript of a duet that Stevenson wrote for Michael and Victoria's children, *A Piece on the Names Ben and Gemma*.

It may have been the experience of painting Rushforth that inspired Victoria to paint the poet Kathleen Raine [cats 9 and 10]. She was introduced first to the poet's work and then to the poet herself by Chris Hall, sculptor of the Bushman figure in the Rushforth portraits. She also recognised the common ground between Raine and Rushforth, and indeed the two women knew of each other and shared an interest in Jung and the unconscious. Perhaps for Victoria, Raine also opened Rushforth's interest in spirituality towards poetry. She first painted a simple study of her which was included in an exhibition of *Twentieth-Century Women Poets* at the Camden Arts Centre in London. The National Portrait Gallery in London expressed an interest in the picture, but Victoria was determined to paint a more extended portrait.

Painted in 1984, the result is a complex, ambitious and very successful work. Raine's present self is in the right foreground looking a little abstractedly to the left. The space is bounded by the wall of her room receding at a diagonal, and a shaft of sunlight projects the shadow of the leaves of a tree outside. Like the pot plants in the Rushforth portraits, it is a reminder of the mundane world outside. However, most of the space behind the sitter is taken up by a large baroque mirror, a gift from the painter Winifred Nicholson. Here the luminous space in the mirror presents a 'mindscape': not a simple

optical reflection, but an inner reflection, a reverie on the sitter's life. She reappears three times in the mirror behind her. Firstly in the near foreground as the startlingly beautiful girl who inspired passion among the undergraduates at Cambridge. Then twice above in middle age, as a head and again seated with hands folded. Much else is happening too, though. A distant landscape is visible and there are seashells and fragments of Celtic interlace. There is also a passage from Raine's poem *The Moment* written on the canvas just behind her head. The skeleton of a bird alongside picks up the image in the lines written there: 'And the lark's bones/Fall apart in the grass.' The skeleton perhaps also hints at a darker undertone in the sitter's life. Top left, as though projected in the sunbeam, is Blake's print *What is Man?*. This refers to the sitter's interest in Blake and her celebrated writing on his work. But perhaps also, if it were a gender-neutral question, or indeed rephrased *What is Woman?*, it might be a motto for these three remarkable portraits, this one and the two of Rushforth.

After the purchase of Rushforth's portrait for the Scottish National Portrait Gallery, Duncan Thomson, the then Director, wanted to commission a portrait from Victoria. His first choice was the veteran Labour politician Jennie Lee. It would have been a great addition to the national collection, but sadly it fell through due to the sitter's ill health. This disappointment however was followed in 1984 by a commission to paint the psychiatrist R.D. Laing [cat.13], author amongst many other works of *The Divided Self* (1960), a book that had earlier attracted Victoria's attention for its relevance to the condition of a friend. Laing had a reputation as a maverick, however, and not entirely without reason. It is a striking picture and the artist has captured the uncompromising force of the sitter's piercing gaze. He is in his study with a window behind him, though as it is a little to one side the light falls on the side of his face. Laing was a fresh-air fiend, and a slight difference in tone between the painting of the top and bottom sashes reveals that the lower one is pulled right up and the window is wide open. He is wearing a favourite cardigan. (The artist had to borrow it to make a rather beautiful study.) On a shelf behind him stand an icon of Christ, a metronome, a piece of rock crystal and a postcard of

Blake's painting of *Eve Counting the Birds*, the latter a link perhaps to Raine. In the bottom left-hand corner of the picture, the cover of his book, *Politics of Experience and The Bird of Paradise* (1967), is just visible. It shows beneath the title and within the outline of a human head, an all-seeing eye and a naked, struggling couple from Hieronymus Bosch's *Garden of Earthly Delights*, 1490–1500. Another of the threads joining these remarkable portraits, this image is a link in turn to Rushforth's vision of inner darkness.

Following her paintings of the two formidable women, Rushforth and Raine, Victoria became fascinated by the personality of Dame Janet Vaughan [cats 18 and 19]. She saw her interviewed in the BBC television series *Women of Our Century* (1984) and she turned out to be the aunt of a friend. Through that friend, Victoria was able to arrange a meeting. Dame Janet was a very distinguished physiologist. Amongst her many achievements were her work on anaemia and blood transfusion, her initiative in setting up national blood banks in London just before the outbreak of the Second World War and, after the war, her work on radiation. She had also experienced directly the darkest side of humanity when in 1945, working on the effects of starvation, she was sent to give medical assistance at the recently liberated Bergen-Belsen concentration camp.

Like Laing, she is painted full-face confronting the viewer with a fiercely intelligent and penetrating gaze. She is wearing a beautiful tweed jacket and silk scarf and, on a chain around her neck, a stone that is a memento of the Spanish Civil War in which she had served as a nurse. On the table beside her, referring to her work on radiation, is an illustration of an irradiated bone. The spine of a book titled *Plutonium* is also visible. On the wall behind her is a beautiful print of a night-blooming cereus from Robert Thornton's *The Temple of Flora*, published in 1807. Dame Janet's father was a cousin of Virginia Woolf and so through him she was connected to the Bloomsbury Group. References to that connection are made in the spines of books on Vanessa Bell and Julia Margaret Cameron who was Virginia Woolf's great-aunt. Fine china, represented both by an empty tea cup in front of her and on display on the shelves behind, softens and lends both

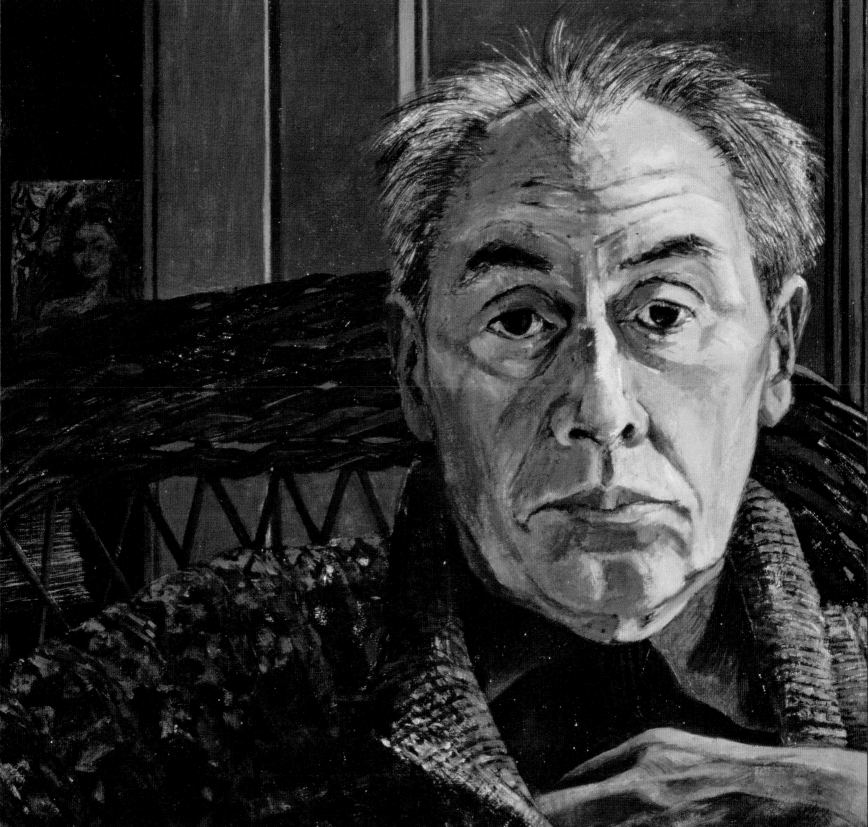

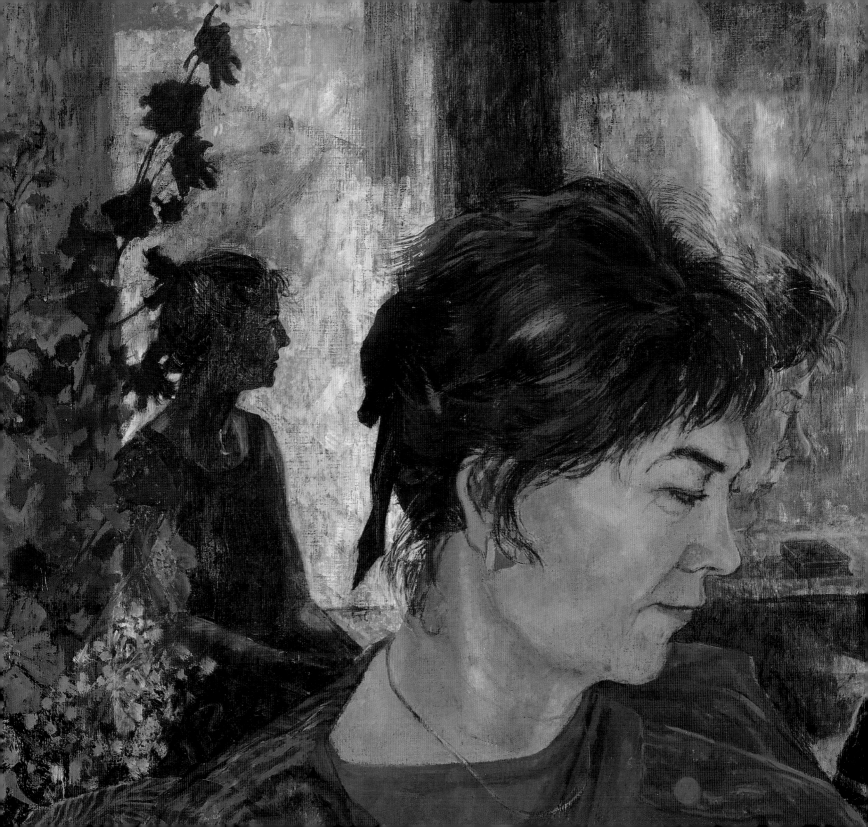

a social dimension and a certain domestic delicacy to her otherwise formidable presence. Like the portrait of Raine, this picture, too, was acquired by the National Portrait Gallery in London.

Up to this time the portrait of Laing was the only one by Victoria to result from a public commission, but in 1986 she received a commission from Edinburgh University to paint the Very Reverend John McIntyre [cat.16]. This was followed in 1987 by a commission from West Lothian Council to paint the county's MP, Tam Dalyell [cat.20], and in 1988 from the National Trust for Scotland to paint the Earl of Wemyss, its chairman and a leading figure in its history [cat.22].

Dean of the Knights of the Thistle, Professor of Theology and sometime Principal of New College, the Divinity School of the University of Edinburgh, the Very Reverend John McIntyre was a distinguished theological scholar. In 1982 as Moderator of the Church of Scotland, he conducted the historic meeting with Pope John Paul II during the latter's visit to Scotland. It was the first such meeting of the heads of the two churches since the Reformation in the sixteenth century, and with quiet humour he held it in the courtyard of New College under the looming statue of John Knox.

Continuing her interest in spiritual matters, Victoria was attracted by her sitter's standing as a theologian. Perhaps, however, because it was her first official commission, she treats him rather formally. Unlike her other portraits, he is not in his personal environment, but is standing, hands folded in front of him, beneath one of the stained-glass windows designed by Douglas Strachan for the New College Library and representing the battle between good and evil. Although the portrait is only three-quarter length, its upright shape adds to its formality. He is wearing the Chain and Order of the Thistle and the spectacular robes of his office as Dean, in dark green, scarlet and white. All this formality is offset however by the man himself. The tilt of his head and his direct but almost quizzical gaze suggest his kindly and engaging personality.

For both the portraits of Dalyell and of the Earl of Wemyss, Victoria seemed to look to Renaissance models for inspiration, though to the Northern rather than the Italian Renaissance, later such an inspiration in her painting. Dalyell's portrait [cat.20] was painted at the House of the Binns, his historic home in West Lothian. He is seated by a window framing green fields, the Forth and the hills of Fife beyond. A shadow on the grass traces the house's striking silhouette. This device of joining sitter and landscape has many precedents in the fifteenth and sixteenth centuries. By coincidence, yet appropriately, there is a sixteenth-century example in the portrait by Arnold Bronckhorst, the Dutch painter who was court artist to King James VI, of another uncompromising Scottish politician, James Douglas, Regent and 4th Earl of Morton, with Tantallon Castle and the outer Forth estuary framed by the window behind him.

In Dalyell's portrait, the artist has caught her sitter's appearance so well that you can see that he knew it was his job to pose, but he would rather have been active than sitting quietly. A pile of books and magazines on the table beside him reflect his engaged and passionate political life. They include two of his own books – *Misrule* and *One Man's Falklands* – and a copy of the Labour politician Richard Crossman's diaries: Dalyell had begun his parliamentary career as Crossman's Parliamentary Private Secretary. Two issues of *New Scientist* reflect the interest in science that had led to Dalyell's book *A Science Policy for Britain*, published in 1983.

The painting of Dalyell led a year later to a double portrait of him with his wife Kathleen [cat.21]. In it, Victoria makes use of a combination of quite precisely seen conventional picture space and still life with something more fluid. Tam and Kathleen are playing chess. Raeburn used the same device in his portrait of General Francis Dundas and his wife Eliza Cumming. In both pictures, too, the wife is clearly winning the game. Raeburn has her looking up in quiet triumph at her final move. Victoria paints her looking down, though with the same quiet satisfaction at her evident victory. In both pictures the husband looks correspondingly a little perplexed. Here the painting of Kathleen Dalyell is particularly beautiful. Both sitters are seen again, from behind, in a mirror. The mirror is also flanked by windows which add to the striking luminosity of the picture. The haze of light and fragmentary detail recall J.M.W. Turner's dazzling paintings of interiors at Petworth, the Earl of Egremont's home in Sussex.

Victoria's portrait of the Earl of Wemyss [cat.22] is a classic rendering of the type of the scholar in his study established by the Dutch painter Quentin Massys's portrait of Erasmus (1517) or by the German–Swiss artist Hans Holbein's *Georg Gisze* (1532). The Earl is seen at home in Gosford House. Seated behind his desk, he is looking up with a characteristically sharp and inquiring gaze as though we have just interrupted him. The papers in front of him – a brochure for Culzean Castle, for instance – relate to his role in the National Trust for Scotland. There is also a packet of deeds tied with a ribbon. A typical still-life detail in a Flemish portrait of this kind, it suggests his work managing the Wemyss estates. In case this implies undue pretension, however, the fine Harris Tweed jacket that the Earl is wearing was bought in a charity shop for £5.

Behind him are shelves of leather-bound books, the subject of a lovely watercolour study. The window opens across Aberlady Bay to Edinburgh and Arthur's Seat, the axis on which the house and its landscape are aligned. To the left, a door opens onto the wide marble staircase that winds around the central hall of the Victorian south wing of the house, the family home after the central block, designed by the architect Robert Adam in the 1790s, was gutted by fire during the Second World War. On the wall at the far left glows a little Renaissance *Madonna and Child*, one small example of the wonderful collection at Gosford House.

As a representation of a male scholar in his study, the Earl of Wemyss portrait was suitably matched in 1990 by that of the patholo-gist Jean Keeling [cat.26], a distinguished woman at work in her study. Keeling was a consultant with the National Health Service for thirty years and is author and editor of several books on foetal and neonatal pathology. The portrait was the result of a private commission.

Like the Earl of Wemyss, the sitter is looking at us with a direct and inquiring gaze. We are immediately in the presence of a forceful and energetic woman. A pen in her hand, she looks up as though we have interrupted her. She is consulting a table in her book *Fetal and Neonatal Pathology*, first published in 1987, for a paper on Parvovirus effects on the foetus. She is dressed, Victoria recalls, in a 'custom-made slub-silk suit chosen specially for the portrait'. Looking at the colour key of the picture and how nicely she tones into it, it is clear that she had thought out how the whole composition would look, set in her New Town home, when choosing her costume. Details also reflect her other diverse interests. She is a serious cook, and a page from a cookery article lies between a notepad and a notebook labelled 'Fetal Pathology'. In the room behind her is a partly reupholstered armchair, a taxing skill which she enjoys.

In 1996, Victoria painted the actor Graham Crowden [cat.33] and the printer and publisher Callum Macdonald [cat.34], and the following year the Danish war hero Ole Lippmann [cat.35]. All three portraits set her subjects in their own, domestic environment. Brought up in Edinburgh, Crowden, who died in 2010, had a distinguished career in the National Theatre, the Royal Shakespeare Company and elsewhere. Wearing a brilliant red shirt with an open collar and braces, he is seated, holding a National Theatre programme. It was, however, his role as a dipsomaniac doctor in the 1980s comic television series *A Very Peculiar Practice* that brought him to the attention of Victoria. Her son Ben had watched and hugely enjoyed reruns of it during his illness. It was in his memory that Victoria painted the picture and, with her husband, presented it to the Scottish National Portrait Gallery.

The portrait of Macdonald was also an indirect commission for the Scottish National Portrait Gallery, but it chimed with the artist's interest in the sitter. Painted at his home in Innerleithen, it was subse-quently bought for the Scottish National Portrait Gallery. The sitter, described as a 'reserved and dignified Gael' by Angus Calder in his obituary in *The Independent*, published many of the most important modern Scottish poets, and in the portrait he is holding a copy of *Lines Review*, the poetry journal that he set up in 1952. Behind him is a cartoon of Hugh MacDiarmid drawn by Sydney Goodsir Smith. Given first to Norman MacCaig and then by MacCaig to Callum Macdonald, it neatly links him with three leading poets whose work he published.

The portrait of Lippmann resulted from an exchange between the Scottish National Portrait Gallery and the Danish National Portrait Gallery in 1997. As a young man during the Second World

Victoria Crowe '16

War, Lippmann became Special Operations Executive leader in the Danish Resistance. He played a leading part in the escape to Sweden of the vast majority of Denmark's Jewish population. He also took the fateful decision to ask the Royal Air Force (RAF) to bomb the Gestapo headquarters in Copenhagen, as it turned out just weeks before the war's end. The low-level, precision raid by RAF Mosquitos was one of the most skilled and daring air-raids of the war, but when one of the aircraft hit a lamp post (the raiders were flying that low) and crashed into a nearby school, tragically, their target obscured by the smoke, other pilots mistook the school for it, killing fifty-six children. It was an accident that haunted Lippmann, but he remained one of the heroes of Denmark's war.

Lippmann was eighty-one when Victoria travelled to Skagen in the far north of Jutland to paint his picture. Skagen had been home to an artists' colony in the late nineteenth century. Painters like Peder Severin Krøyer went there attracted by the light and it filled their painting. In Victoria's picture this same light illuminates the lovely blue and white interior of Lippmann's home. Actual sunlight catches a curtain at the window behind the sitter, but magnifying the luminosity, light is also reflected in a mirror on the wall and on two glass-topped tables. (This interior is also the subject of several watercolour studies.) In eloquent contrast to all this clarity and brilliance, however, looking quizzically at us with folded arms, the sitter himself seems strangely enigmatic. He believed it was his gift of knowing intuitively whom he could trust that kept him alive during the war. Perhaps his inscrutability helped too. It is as though the wartime habit of mystery on which his survival had depended had become second nature and so had stayed with him. It is a tribute to the artist's skill that we can read all this in the portrait.

The *Last Portrait of Jenny Armstrong* was painted in 1986–87 [cat.5]. It demonstrates how Victoria's interest in portraiture had arisen naturally out of her painting and her interest in the sitters she chose: how portraiture was integral to her work, not some kind of branch line off it. It is logical therefore that it also began to feed back into her work. In her second portrait of Rushforth [cat.7], but even more in

her portrait of Raine [cat.10], she was already exploring a new kind of picture space. It was some time however before this began to appear in her painting more widely. When she could, she painted her sitters in their own setting, surrounded by telling details, but she generally organised the picture space to mimic the actual space. In the portrait of Raine, however, she used the mirror in the manner of *Alice Through the Looking Glass*, to lead us into the sitter's life, and this introduced a new dimension to her art. It was a way of using the picture space as a mental space. Things come together there as they do in memory, composed with no reference to the usual conventions of pictorial space.

On the face of it, *Heroes and Villains* [cat.27], a portrait of her son Ben painted in 1991, carries on this approach, but the organisation seems looser, the space more fluid. Ben is standing to the right looking out of the painting to his right. He seems very close to the surface of the painting, and the still life and the window behind him seem to be in the same plane. Although he is not looking at these objects, they seem to be somehow there in his head as much as outside of him. The picture takes its title from a wistful 1967 song by the Beach Boys. The singer thinks back to a place he has left: 'I've been in this town so long that back in the city / I've been taken for lost and gone.' The picture is set in Monksview at Kittleyknowe, but the family had moved to West Linton the previous year; it is already a memory more than an actual scene. The toy soldier and other still-life details might be memorabilia from a boy's bedroom. (The aeroplane, parachutes and columns of smoke visible through the window, however, record an actual event: a sudden and unannounced military exercise on the moor behind the house during the first Gulf War.) Ben was on the point of leaving home to go to Aberdeen University so, in keeping with the song, the picture is about transition. It is a painted poem, an inward space, not an outward one.

By the time Victoria portrayed her daughter Gemma in *Portrait of a Young Woman, Milan* [cat.40], done in 2000, and indeed when she painted her slightly earlier self-portrait, *November Window Reflecting* [cat.32] in 1995–96, this way of filling the canvas with freely structured imagery had become her usual approach to composition. In these

pictures, as she had originally used it in her painting of Raine, this imagery is linked to the presence of the sitter as though it really were a landscape of the mind. The picture space becomes a place where all sorts of things associated with the person who is being painted can be assembled to extend the portrait into other areas representative of their personality and achievements.

This is clearly the case in her painting of the distinguished botanist David Ingram [cat.43], for instance, commissioned by St Catharine's College, Cambridge. Ingram had been Regius Keeper of the Royal Botanic Garden in Edinburgh from 1990 to 1998 and was then appointed Master of St Catharine's. The painting also led to a scholarship at the College. This in turn led to Victoria's exhibition *Plant Memory* at the Royal Scottish Academy in 2007. It was inspired by the historical specimens in Cambridge University Herbarium which she saw as a botanical memory bank. In the portrait, Ingram is standing with a circle of light behind him. It is almost as though he is lecturing and the pasque flower that he is holding is his subject. His purple shirt was chosen to match the flower's colour. A description of it from *Plants of England* (*Catalogus plantarum Angliae, et Insularum adjacentium ...*) by John Ray, published in 1670, is written behind his head. Together with other botanical imagery, a specimen from the Herbarium of *Sibbaldia procumbens* appears prominently in the painting. It is a plant named after Sir Robert Sibbald, a pioneer of Scottish science and one of the founders of the Royal Botanic Garden.

Five public commissions for portraits followed this one: of the composer Thea Musgrave for the Scottish National Portrait Gallery, completed in 2006 [cat.45]; of the historian and librarian Ann Matheson for Edinburgh University in 2009 [cat.46]; of the physicist Peter Higgs [cat.48] and the astronomer Dame Jocelyn Bell Burnell [cat.50], both for the Royal Society of Edinburgh (RSE) and painted respectively in 2013 and 2015–16; and of Sir Tim O'Shea, Principal of Edinburgh University, commissioned by the University in 2017 [cat.51].

In the first four of these, the artist adopted a similar strategy to the one she used in the Ingram portrait. Texts, diagrams, formulae and other imagery is deployed in the field of the picture behind or beside the sitter. In Musgrave's portrait [cat.45] it is a blue-lit stage, the ropes of the flats and other backstage apparatus visible at the top. She herself stands, hands clasped and alert, looking to our right and beyond us as though listening, or perhaps about to speak. The blue light is a memory of the artist's first meeting with the sitter at the Royal Albert Hall in London when her work *Turbulent Landscapes* was being performed there. The portrait was actually painted in the United States, however. During the week of sittings, the composer's husband Peter Mark, Director of the Virginia Opera, based in that state's capital, Norfolk, was working on a new production of Bellini's *Norma*. The artist had the opportunity to watch this through with Musgrave from rehearsal to performance, which inspired much of the detail. For instance, the composer's own opera *Simón Bolívar* had previously been produced in this opera hall, and a line from its libretto is written across the top: 'Por ese nuevo mundo abierto' ('To open a new world).' There is also a page from the score. The various patterns of geometric lines were the composer's diagrammatic stage directions for the placing and movement of the musicians. The head of Mary Queen of Scots hovering to the right is a reference to the composer's opera with that title, but a classical bust is a memory of the gallery in the Chrysler Museum where the portrait was painted. To the extreme right, a figure is silhouetted in a lit doorway. Something actually seen in the theatre, it recalls the mysterious figure seen against the light in the background of the seventeenth-century Spanish artist Diego Velázquez's *Las Meninas*, also a topic of conversation with R.D. Laing.

Until she retired in 2000, Ann Matheson [cat.46] was Keeper of Printed Books in the National Library of Scotland. Her portrait was commissioned by the University of Edinburgh after she had served as Secretary of its General Council from 2001 to 2009 and again from 2010 to 2011. Rapport with her sitters is vital to all Victoria's portraits, but here it is quite tangible. Matheson sits, hands folded in her lap. She is relaxed but alert. The hint of a smile, her expression reveals her awareness of the artist and her responsiveness to her.

por ese nuevo mundo abierto

$$\mathcal{L} = (D_\mu \phi)^* D_\mu \phi - V(\phi) - \tfrac{1}{4} F^{\mu\nu} F$$

$$D_\mu \phi = \partial_\mu \phi - i e A_\mu \phi$$

$$F_{\mu\nu} = \partial_\mu A_\nu - \partial_\nu A_\mu$$

Compositionally the portrait is elegantly simple, consisting simply of three vertical rectangles. Light creates the space. Dressed in dark blue, the sitter is seen against a panel of luminous blue as though against the sky. To the left a narrow rectangle of darker blue closes the composition, while to the right the third panel echoes the tints of white, gold and buff of old documents. The golden tints also subtly match the sitter's buttons and her brooch of gold and blue enamel, the latter picking up the blue of her dress. The right-hand panel is composed of layered documents, inscriptions and fragments of text. The word Rosehaugh and the date 1636 are legible, for instance. Referring to Sir George Mackenzie of Rosehaugh, one of the founders of the Advocates' Library, they are part of an inscription engraved on the window of the National Library staircase. Other details include a map of where Matheson was born in Conchra in Lochalsh in the West Highlands, Sorley MacLean's poems in her native Gaelic, the title page of Adam Smith's *The Theory of Moral Sentiments*, a quotation from Scotland's first printed book *The Chepman & Myllar Prints* (*c.*1508) with the windmill device of the printer, Androw Myllar, the website address of the Consortium of European Research Libraries, a text by the late Ian Hamilton Finlay and much else. It is like a palimpsest of her life and interests.

Because of the esoteric complexity of his subject, the commission to paint the physicist and Nobel Prize winner Peter Higgs [cat.48] seemed at first to be a real challenge, but Victoria found him modest and companionable for all his fame. The very opposite of a celebrity, he looks thoughtful but unassuming. The great success of this portrait is indeed the way it conveys such a convincing sense of the man himself. He is sitting in his favourite Wassily chair. The walls behind him are the olive green of his room. Dating from 1967 and in the fashion of the time, it hinted at the nearly sixty years he had to wait from publishing his radical paper in 1964 till his theory was proved in 2013. There are references to his theory and indeed some of his equations in the space behind him. His ever so slightly stiff pose, with his hands on the arms of his chair, gives us another glimpse of his personality: perfectly at home with the artist, he seems nevertheless not entirely at ease with the

business of being painted. Particle physics is simply unfathomable to ordinary mortals, but here it has an eminently human face.

If in particle physics Higgs is engaged with the inconceivably small, Dame Jocelyn Bell Burnell [cat.50], a very distinguished astronomer, deals in her subject with the inconceivably large. Her portrait was commissioned by the RSE when she was elected its president in 2015, the first woman to hold the office. When still a research student, she identified the anomalous radio signals that led in turn to the identification of pulsars, small and incredibly dense astronomical bodies. She had also helped to build the four-acre radio telescope on which these crucial observations were made. Her portrait is superficially similar in its arrangement to that of Higgs. She is seated to the left, and elements of her principal discovery are portrayed in a kind of projection in the main field of the picture. The main difference from the Higgs portrait, however, is that she is seated behind a desk. Papers are laid out on it. She is holding a pen and she looks up as though interrupted. Above her is a night sky dominated by an image of what a pulsar might look like. Beneath it is the pattern of the astronomical radio transmissions which she had to check endlessly to identify the crucial anomaly from which the existence of pulsars was deduced. The roll of paper on her desk also recalls these endless printouts. Behind her are images of the radio telescope she helped build. The desk subtly distances her from us, however, and she too seems a little withdrawn, as though reminding us that her public and private spheres are distinct and the portrait belongs to the former.

This was certainly not the case with Sir Tim O'Shea [cat.51], or at least he does distinguish between public and private, but he also allowed both to appear in his portrait. On the left he is seen in profile in the suit that he wore to work as Principal of the University of Edinburgh. On the right he is full face in the old green jacket that he favours off duty. Perhaps too it was to accommodate his vitality and engaging enthusiasm that Victoria ended up painting what is by far her largest portrait. The airy, fluid space and the way things seem to drift through it, often overlaying each other, are typical of much of her other work.

The picture is a double square painted across two canvases, and the composition is roughly divided into seven vertical panels. Mostly transparent, the exception is a flat grey panel to the right. Sir Tim is standing against this in his off-duty jacket, arms folded, static, but also by the look in his eyes a little restless, mercurial, ready to be off to show yet another achievement of his time in office. To the left, the view of his profile and the way it sits in the painting is a device Victoria has often used. The dome of the McEwan Hall is visible beyond him, and the Castle beyond it in turn. The recent and successful refurbishment of the McEwan Hall, the University's graduation hall, is a matter of great pride for him. Diagrams beneath this refer to a quite different kind of achievement, his work on computer science and robotics. In the central panel is an actual robot. Designed for NASA to walk on Mars, and an immensely important commission for the University, she is called Valkyrie. With all these things flowing effortlessly together into a single image, any distance that there may have been between Victoria's portraits and the rest of her work is gone. The two things elide seamlessly.

If Sir Tim's portrait was a major public commission, in 2016 Victoria also fulfilled a major private commission when she painted a double portrait of the Duke and Duchess of Buccleuch [cat.49]. The Duke had long been a collector of her work. She painted the portrait at Bowhill House which is also home to a remarkable collection of portraits. Thomas Gainsborough and Sir Joshua Reynolds seem to have set up a rivalry working for the Montagu family, and the results hanging together in Bowhill would be a challenge to any portrait painter. Victoria meets the challenge, though perhaps not head-on. That would be impossible. In the eighteenth century social status was part of the image in a way that it can no longer be. Instead, her portrait quietly and unostentatiously evokes the long history of the family.

The Duke and Duchess are seated behind a table. Behind them a mirror reflects a handsome room and beyond it a view out into the Buccleuch estates. In a separate mental space to the left of the mirror, a beautiful full moon rides in a deep blue sky. It shone at Bowhill while the picture was being painted. The picture is also richly layered with references to the Buccleuch family's long engagement with Scottish art and letters. An inscription legible against the mirror, for instance, is a dedication written by Adam Smith to the 3rd Duke in a copy of his *The Wealth of Nations*: 'To the Duke of Buccleuch from the Authour.' The table in front of the couple is an ancient, leather-topped writing table covered in ink stains left by generations of the family. Some spines patched with black tape, the leather-bound books behind the Duke look well used. These details suggest that for all the grandeur, this is a domestic and working environment, but also an ancient one. The books on the table in front of the Duke are the three volumes of the first edition of *Waverley*, published in 1814. They were presented to the 4th Duke, a friend and supporter, by their author, Walter Scott. As the book was published anonymously and Scott was still the 'great unknown', the volumes are unsigned. Scott had to pretend he had found them in a bookshop and thought they might be of interest to the Duke. In the painting, the present, 10th Duke is consulting letters in packets tied with pink tape. They are from a vast correspondence written by the wife of the 5th Duke to her husband.

Duke Richard is in his shirtsleeves, but his wife is wearing a brilliant Paisley-pattern jacket. There is a lovely painted wallpaper of birds behind her, though lower down it seems a little the worse for two and a half centuries of wear. The Duchess is engaged on a drawing. The book to her left is a candidate for the Sir Walter Scott Prize for Historical Fiction established by the Duke and Duchess in 2010. As she looks up and past us, the Duchess's pose and the way she holds her pencil are once again distinctly reminiscent of Northern Renaissance painting. There are precise, but no doubt unconscious echoes of both Holbein's Erasmus and Massys's *Portrait of a Man* in the Scottish National Gallery, locating the portrait in a long and distinguished tradition. If the Duchess seems a little withdrawn, the Duke engages us. Sitting slightly forward of his wife, he seems almost protective of her. Here too, we see how the poetic vision and insight that informs all of Victoria's painting also richly informs her portraits.

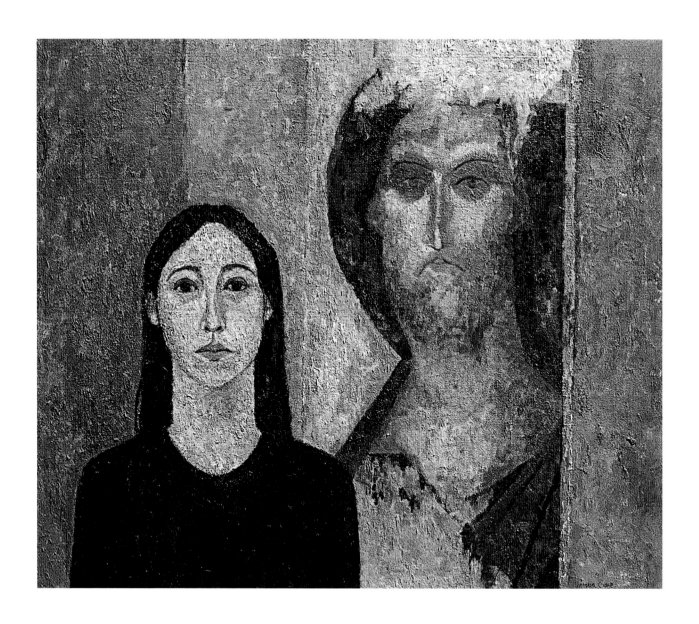

1 Self-portrait with Icon

1964–65 · oil on board · 96 × 110 cm
Private collection

2 Michael Walton

c.1970 · oil on board · 46 × 38 cm
Collection of the artist

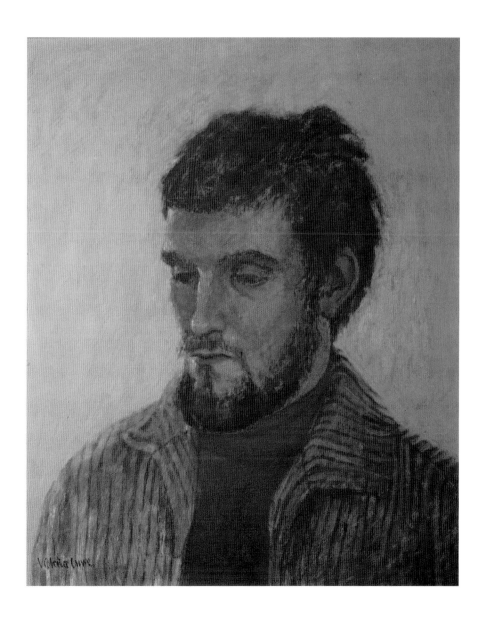

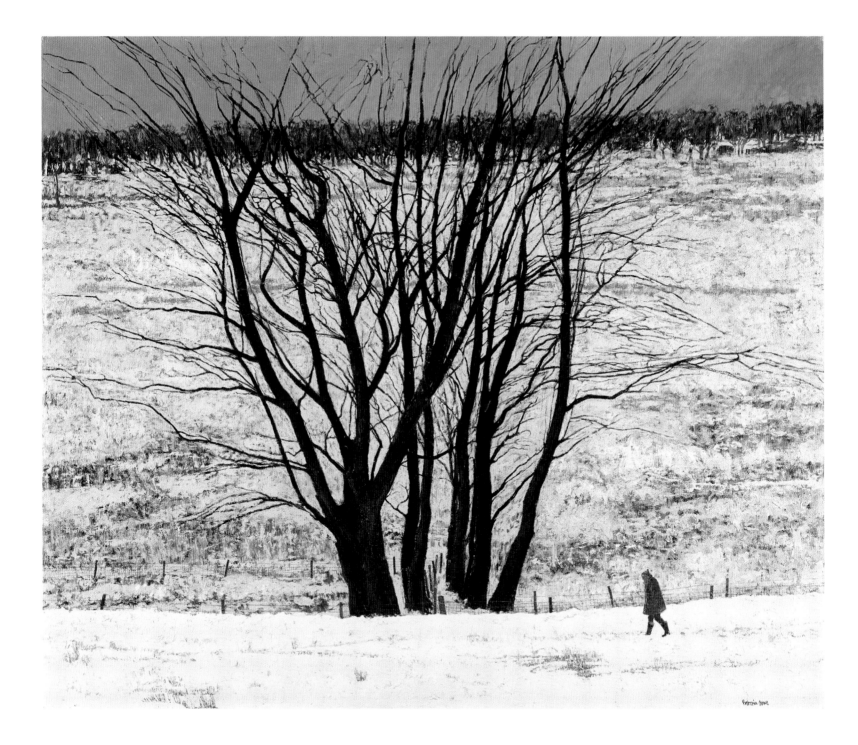

3 Large Tree Group

1975 · oil on board · 91.4 × 111 cm
Scottish National Gallery of Modern Art, Edinburgh;
presented by Mr and Mrs John Butters through the Patrons
of the National Galleries of Scotland, 2015

4 Jenny at Home

1982 · watercolour on paper · 49.5 × 40.5 cm
Scottish National Gallery of Modern Art, Edinburgh;
presented by Victoria Crowe and Michael Walton through
the Patrons of the National Galleries of Scotland, 2015

JENNY ARMSTRONG (1903–1985)
Shepherdess. Spent her whole life working as
a shepherdess in the Pentland Hills. Victoria
Crowe made a series of paintings of Jenny, a
neighbour and a friend, created over twenty
years and first exhibited at the Scottish National
Portrait Gallery as *A Shepherd's Life*, 2000.

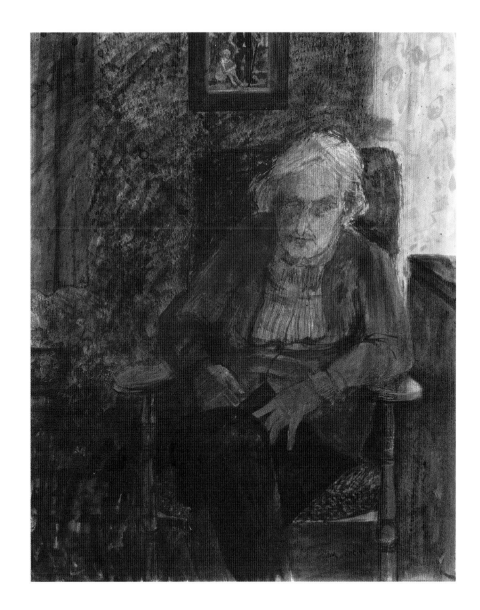

5 Last Portrait of Jenny Armstrong

1986–87 · oil on board · 143 × 112 cm
City Art Centre, Edinburgh Museums and Galleries;
purchased with the assistance of the Jean F. Watson Bequest Fund
and the National Fund for Acquisitions, 2007

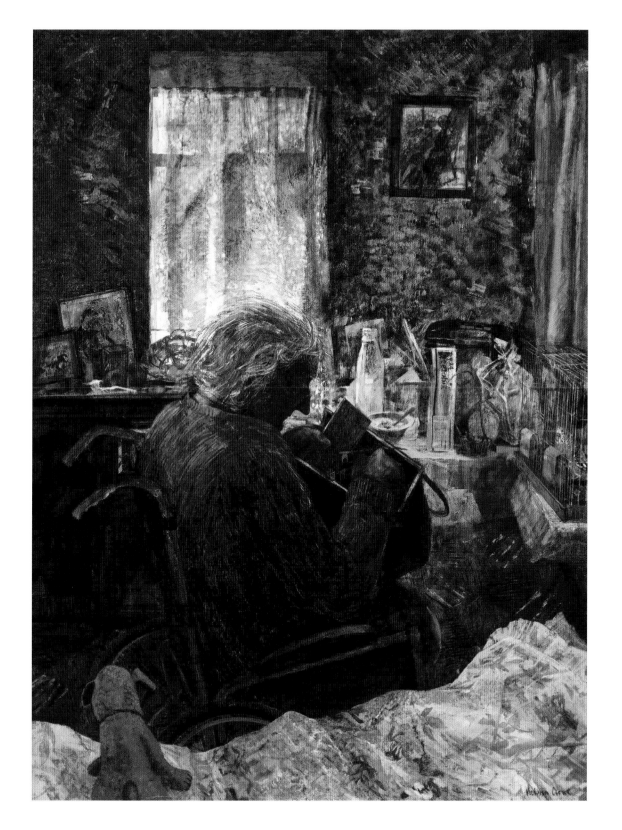

6 Winifred Rushforth

1981–82 · oil on board · 83 × 103 cm
City Art Centre, Edinburgh Museums and Galleries; purchased with the assistance of
the Jean F. Watson Bequest Fund and the National Fund for Acquisitions, 1982

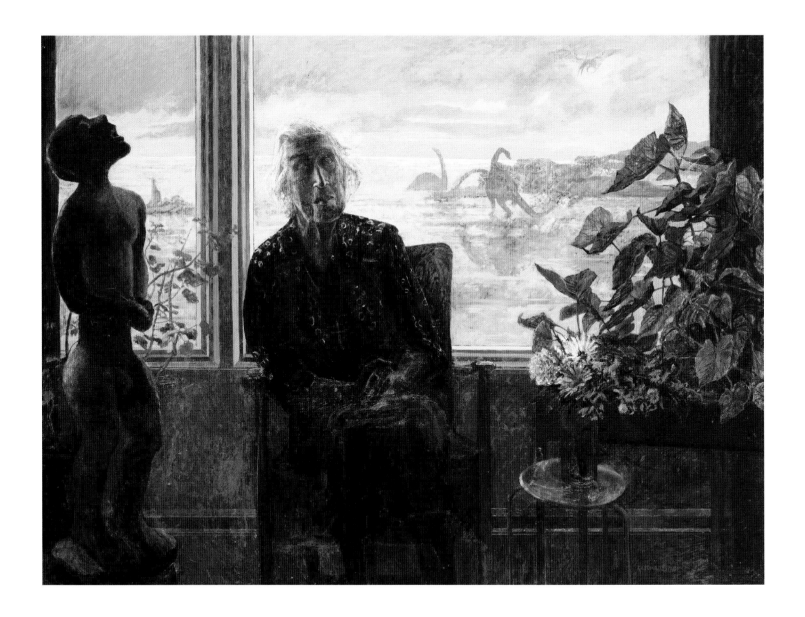

7 Winifred Rushforth

1982 · oil on board · 56 × 76.3 cm
Scottish National Portrait Gallery, Edinburgh

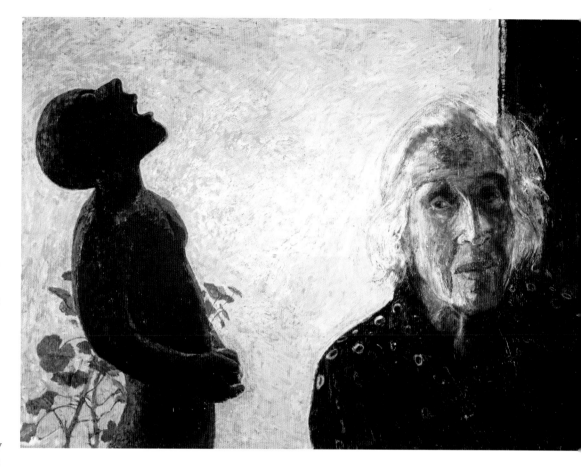

The first time Mike and I met Winifred was at her ninety-fourth birthday party in Edinburgh. She was sitting, dressed in a black lacy outfit, the central focus of a huge crowd of young and old, medics and friends, children and babies, physicians and patients. By the time I began painting her, we had been to many of her dream groups and I was learning about the work of Jung, of symbolism, myth and the unconscious, and realising how important these aspects were to my own creative thinking.

At that time Winifred began holding a dream group for a neighbour in Carlops who had had a stroke in his forties. She was driven out each Saturday and came to my studio for two or three post-group sittings which she managed, after a quick nap. The drawings and sketches from her home in Lauder Road provided me with more information and show her against the light-filled upper window with the silhouetted Bushman sculpture beside her. The rampant begonia behind her in the City Art Centre's portrait lives on nearly forty years later, as a vigorous cutting, filling a window in our own house. The smaller portrait I painted of her, now in the Scottish National Portrait Gallery, was completed at Monksview and shows the thicker studio window frame behind her, so she is half back-illuminated as well as silhouetted, which I thought gave a powerful focus for showing all Winifred's strength and energy. (At her funeral over a year later, 'Strong as a Mountain' was spontaneously sung.)

Winifred was nearly blind at the time of the sittings and so couldn't see the work in detail, which gave me a great freedom in my interpretation of her. She wrote: 'Age is measured not by the fragility of the bones but by the strength and the creativity of the psyche.' This was the subtext to both of those portraits. It was a phrase that Winifred used herself many times. She guided me towards a greater understanding of the human condition and the search for meaning. Light is therefore of prime importance in these two works.

DR (MARGARET) WINIFRED RUSHFORTH (1885–1983)
Psychoanalyst. Worked in India as a medical missionary and surgeon specialising in women's health. Honorary Medical Director of the Davidson Clinic, Edinburgh 1939–65, focusing on therapeutic approaches in mental health. Influenced by Carl Jung and analytic psychotherapy.

8 Marion Pulford

1982–83 · oil on board · 90 × 78 cm
Collection of the artist

Marion Pulford was a friend of my mother, who lived near us in Carlops. Visually I found her fascinating and she came to sit for me. She put me in mind of the work of my Royal College of Art tutor Carel Weight, whose deeply psychological portraits I admired, with all their atmosphere of unspecified tension and angst. He saw the unease of the sitters within the completely ordinary places of gardens, streets, domestic interiors – a perception of the inner self. Having become interested in such aspects myself, I was very pleased to work with Miss Pulford. She found the process of being painted interesting and we talked during the sittings about art and plants. She was, despite her diminutive size and frail body, a passionate gardener, digging and hefting huge shrubs around her garden in Carlops. She suffered greatly, however, from anxiety. The portrait is about that state of mind and mental fragility within her tiny bird-like body. Her neck and shoulders are too small for that blouse, her hands tense on her lap, her eyes focused deliberately away from me. Her backlit long white hair reminded me of a bride's veil.

When the portrait was exhibited at the Morrison Portrait Award at the Royal Scottish Academy, another older artist on seeing this painting referred to it as 'charming' … I thought I had totally failed in what I was trying to do!

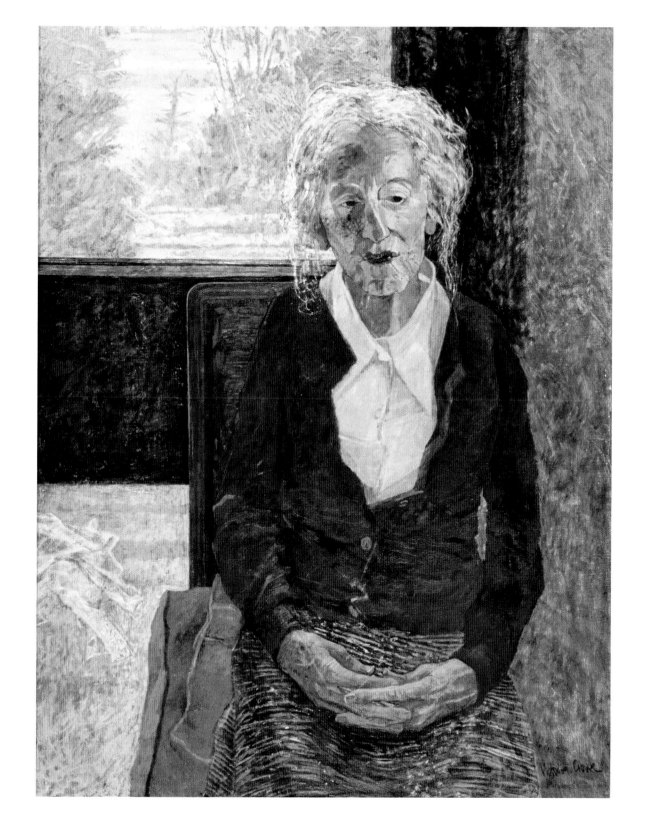

9 Kathleen Raine

1983 · pencil and oil on paper, 44.5 × 34.9 cm
Scottish National Portrait Gallery, Edinburgh

10 Kathleen Raine

1984 · oil on board · 115 × 91 cm
National Portrait Gallery, London

I was introduced to Kathleen Raine after being asked to put some work into an exhibition of paintings of poets at Camden Arts Centre. I did a study of her in her home in London and the more I learnt of her, the more I read the poetry and autobiographies, the more I wanted to do a painting which could be more than a physical study.

Kathleen's poetry struck a chord with me; her almost Christian-mystic regard of landscape and the natural world made for some very powerful word images. She was deeply intellectual too, imbued with the philosophy of Plato and Plotinus, and was an acclaimed scholar of William Blake. There was so much to her personality and understanding that I could barely touch. She openly acknowledged wilfulness and passion, intellectual elitism and lack of sympathy, but her work transcended much of this, having a clarity of experience and authenticity of feeling about it. One aspect of Kathleen's work to which I responded was her acknowledgement of the importance of memory, of time passing, of the fragility of the moment. She had an ability to communicate these thoughts very strongly, using visual juxtapositions of images. Her sequence *On a Deserted Shore* is a powerful poem about loss. She had loved Gavin Maxwell but that had ended disastrously and destructively: 'ring of bright water' is a phrase from one of Kathleen's poems that he used for the title of his famous book about a family of wild otters in Scotland.

She had read Botany at Cambridge University where her beauty earned her a group of followers, 'the Kathleen Raine appreciation society'. She had married Charles Madge (of the social research organisation Mass-Observation) and had two children, whom during the war she left in Cumbria when she went to London to 'be a poet'. So there were hugely conflicting responses to her the more I read and the more time we talked together during the sittings. She had been friends with many artists and writers and shared links to Winifred Rushforth through her interest in Carl Jung and the Jungian mystic Laurens van der Post, among others. It was no surprise to find her upstairs lodger was the visionary painter Cecil Collins, who crept down the stairs in a long raincoat on his way to the shops in Chelsea. The wonderful old Venetian mirror was given to her by the painter Winifred Nicholson.

We had some problems with the big portrait. Having felt that beauty and passion had brought much pain in her life, she wanted me to 'emphasise the intellect' (brow) and to 'subdue the sensual' (mouth), which of course I couldn't do. She told me that she didn't like being looked at, so her gaze is averted. She was immersed in Indian philosophy at that time and was wrapped in a deep-coloured Indian shawl during the sittings. The mirror behind her, which dominates the painting, was one way that I felt I could get closer to her complex and contradictory nature. It reflects three ages of her life, images of rock rose, fossil and stone and part of the poem called *The Moment*, which I found completely absorbing.

Her work has stayed with me but I felt I could never touch the intensely spiritual but flawed and possibly unhappy person. We corresponded over the years, and when my son died some eight or nine years later she sent me a very thoughtful letter and talked to me of the prose poems I had written during that period. In some ways she had already experienced the territory I was passing through.

KATHLEEN JESSIE RAINE (1908–2003) Poet, critic and scholar. Her poetry explores the intersection of science and mysticism. Her scholarly works include writings on William Blake and W.B. Yeats. Founder of the journal *Temenos,* Temenos Press and Temenos Academy of Integral Studies.

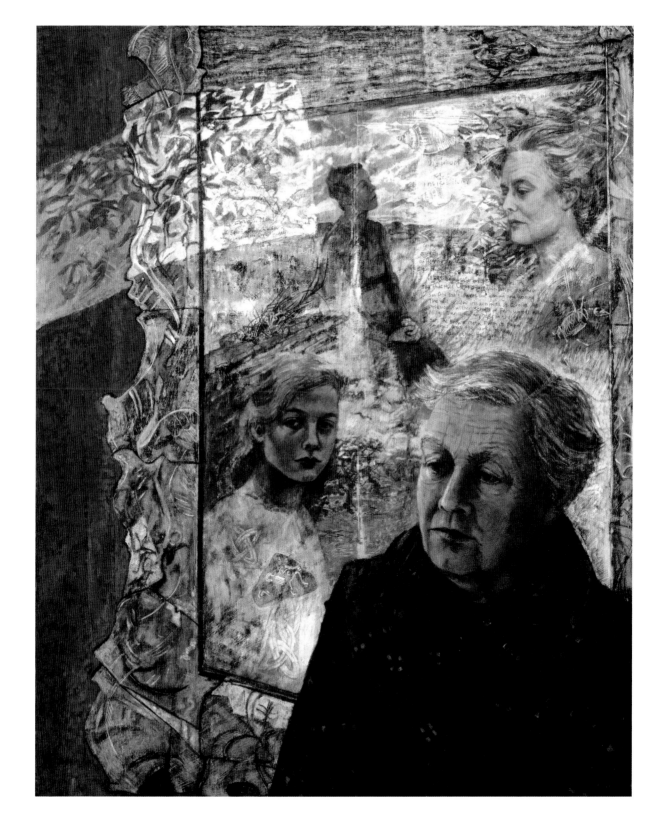

11 Ronald Stevenson

1983 · oil on board · 71.2 × 91.4 cm
Scottish National Portrait Gallery, Edinburgh

Ronald was teaching my son, Ben, to play piano at the time this portrait was painted. He didn't just teach him to play but taught him musicality and gave him a love of music which became a hugely important part throughout Ben's life. I wanted the portrait to be a tribute to Ronald's teaching and also to his music and its associations and influences.

The first drawings of the room were dominated by the single light source of the window from West Linton Main Street (six years later we would move to the house opposite and become his neighbours). Ronald was an acclaimed composer of contemporary music. Many poets, musicians, intellectuals and writers of international repute frequently met in that traditional cottage room in the Borders village. One of his great friends the poet Hugh MacDiarmid lived further down the road at Candy Mill: he is referred to in the portrait by an image of a photograph. During the sittings, we talked about Scottish poets, especially Sorley MacLean, and of music: Busoni, Shostakovich, Grainger – all the musicians whom Ronald admired. Ronald Stevenson's famous *Passacaglia on DSCH* was played frequently in my studio as I worked. The colour in the painting was, in my mind, dominated by the harmony in the music, the light from the window on his own rather high colouring and the turquoise/alizarin of his shirt and waistcoat. The Amerindian necklet he wore kept reminding me of the breadth of his musical interests – world music, connections with China, Switzerland, Russia

and of course Scotland. There are references to international festivals, Ronald's recordings and performance programmes in the painting. There is a small framed image referring to the marriage of Ronald and Marjorie – that wonderful woman, originally a musician herself, who kept the family and the outside world in balance with her husband's inner creative one.

Ronald had an unflinching gaze and a formidable intellect. The pose is quite heroic, the expression confident. While dependent on the back light source, he was united with the atmosphere of the whole room and therefore not dominating or separated from the experience; paradoxically this lighting gives the figure tremendous power and strength, holding the complete composition of all those facets with a direct, concentrated gaze.

The presentation in the Scottish National Portrait Gallery was memorable with the children unveiling the portrait, while John Ogdon, that pianist of huge international status and great friend of Ronald and Marjorie's, played one of Ronald Stevenson's compositions.

RONALD STEVENSON (1928–2015)
Composer, pianist and teacher of music. Known for writing one of the longest unbroken single movements composed for piano, *Passacaglia on DSCH* (1960–62). *In Praise of Ben Dorain,* a choral symphony based on Hugh MacDiarmid's translation of a poem by Duncan Ban Macintyre; performed in 2008 by the BBC Scottish Symphony Orchestra and Chorus.

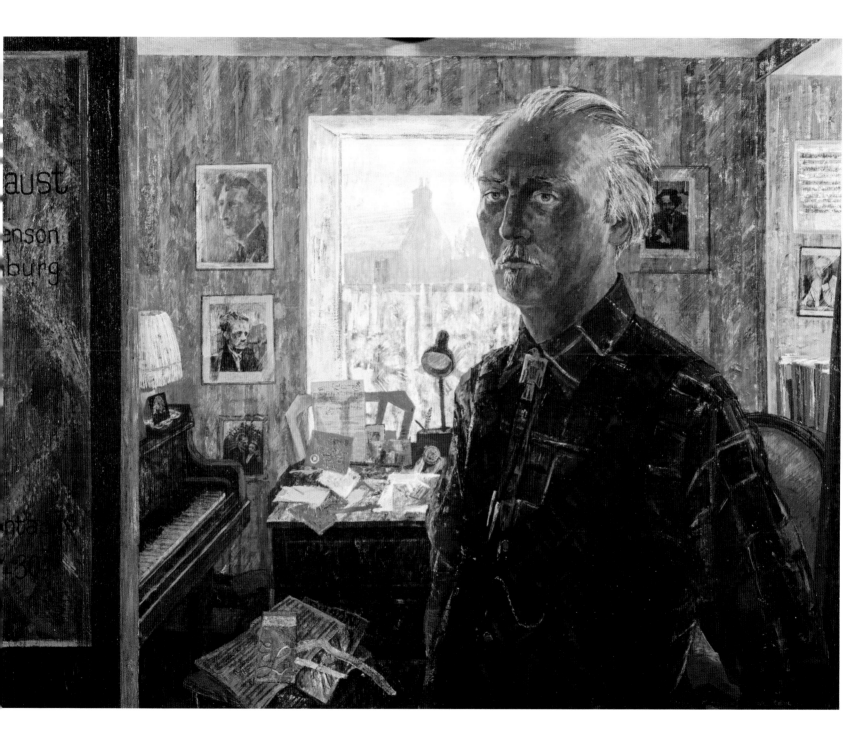

12 Patrick Bourne

1984 · oil on board · 80 × 70 cm
Private collection, courtesy of Patrick Bourne & Co., London

We had known each other for several years
before I painted Patrick in 1984. At that time
he was already a keen collector of art and had
established Bourne Fine Art in Edinburgh.
He subsequently went on to become Director
of the Fine Art Society in London, and now
deals independently. The portrait was made in
his New Town flat and shows a painting from
his collection in the background: an image
of the First World War titled *Motor Transport
Repair Workshop, German East Africa*, *c.*1919, by
James Hamilton Mackenzie. In the portrait,
Patrick seems to be thinking of other things,
other places, which links it in my mind to the
young soldiers drafted to foreign lands. I felt,
when I was painting, that there is a palpable
sense of vulnerability around young men at the
beginning of their lives, and recognised this
when I painted my own son several years later.

I like the painting of the head very much,
and this portrait remains one of the few
showing the sitter at the start of their career.

PATRICK BOURNE (B.1952)
British Art specialist and dealer. Founder of
Bourne Fine Art, Edinburgh, 1978; Director
at the Fine Art Society London until 2014
when Patrick Bourne & Co. was established in
London.

13 Ronald David Laing

1984 · oil on board over acrylic underpainting, 91.4 × 71.1 cm
Scottish National Portrait Gallery, Edinburgh

My relationship with R.D. Laing's writings went back some twenty years earlier to student days at Kingston School of Art when a fellow student developed schizophrenia. I had read *The Divided Self* and *Self and Others* and was fascinated by the new perspectives on the mind that these works revealed. I can't say that I understood what was happening to my friend but the power of our inner lives, our perceptions and desires was a revelation. So I was delighted to receive the commission to paint Laing in 1984 from the Scottish National Portrait Gallery.

When we first met at Dr Diana Bates's house in Edinburgh, my internalised image of Laing –measured, considered, intellectual, grave – was rather shattered. Di (Winifred Rushforth's daughter) knew Ronnie well. A fellow psychoanalyst, Di had worked with him in the '60s trialling the use of LSD as a therapeutic drug for the mentally ill. She had fortunately arranged an informal social meeting before the agreed commencement of the sittings in London the following month. Shambling, not making eye contact or taking my proffered hand, my would-be sitter diffused any pretensions or social chat that the evening might have held! However, I instinctively knew to just observe and not judge, to be open to this aspect of him … and by the end of the evening we were great pals: lots more red wine had been drunk, some music, long stories and laughter and he disappeared into the night in his crumpled raincoat and with a flapping sole

to his shoe. This shoe was relevant and had its effect: when I next met him at his home in London he had a great gash to his nose, the sole having tripped him up on the spiral stairway. But he relished the irony – to sit for a prestigious collection with a bloodied nose, another diffusion of any pretension. There are many layers and levels to the portrait, and I continued to read his works – *The Politics of Experience*, *Knots*, *Conversations with Children*, *The Bird of Paradise* and others – up to and during the sittings.

The sittings took place in his study (not his consulting room which had a dentist's chair in it – whether for him or his patients I don't know). It was early in the year, March I think, and the London trees were still bare. The room itself was full of books, articles and papers spilling all around the skirtings. A grand piano dominated the space behind me, and he regularly got up to play it. After initial awkwardness, when he wanted me to remove myself from his space at the end of the first sitting, we assumed an easy relationship. He was a conscientious sitter, and I was a permanent fixture in his study for the rest of the week. I chose an uncomfortable position kneeling before him (!!) as I realised that the most intense and direct expression was evident when he was slightly above me. He meditated with wide-open eyes for some of the time when we were not talking – there but not there – and at other times was completely and perfectly there, when we talked about his work, his spiritual search, about male–female

aspects, about the art of Velázquez and the nature of illusion and reality. I included some of the objects in his room: for example, the crystal which he used when I was there was to get a new or alternative perspective. The *Vernicle*, that complex thing, an icon, a non-realistic painting of a mystical impression on a piece of cloth; and William Blake's *Eve Naming the Birds*, the female aspect in creativity – these were among the things considered and spoken of.

He told me that he searched for vertical wrinkles on his brow to make crosses when a friend had said that he would never be a Christian until the crosses appeared. He was restlessly concerned to find a spiritual and intellectual truth that he could apply to his model of existence. Looking at the painting now, I still feel the presence of the man so strongly. He's so physically rooted in that work, but with a spinning movement of ephemeral thoughts, links and possibilities around him.

DR R.D. (RONALD DAVID) LAING (1927–1989)
Psychiatrist and writer. Became known for his rejection of conventional treatments for mental illness; a great advocate for patients, he opposed the imposition of lobotomies and electric shock treatment. Set up the controversial residential community Kingsley Hall in 1965, treating patients for schizophrenia. Wrote the bestselling book *The Divided Self* (1960).

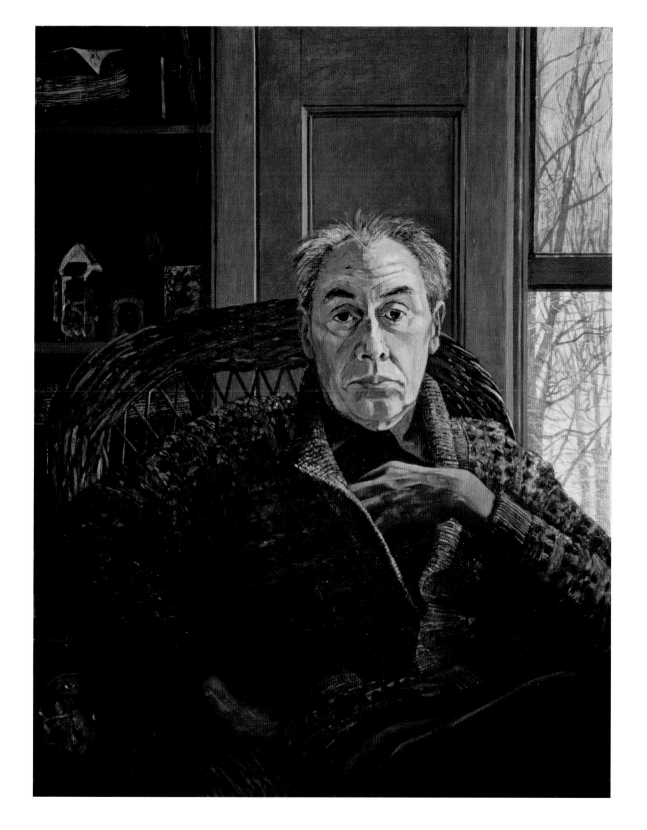

14 R.D. Laing: studies of cardigan

1984 · pencil and watercolour · 42 × 60 cm
Collection of the artist

15 Photographs of Victoria Crowe working with R.D. Laing, by Michael Walton

1984 · Scottish National Portrait Gallery, Edinburgh

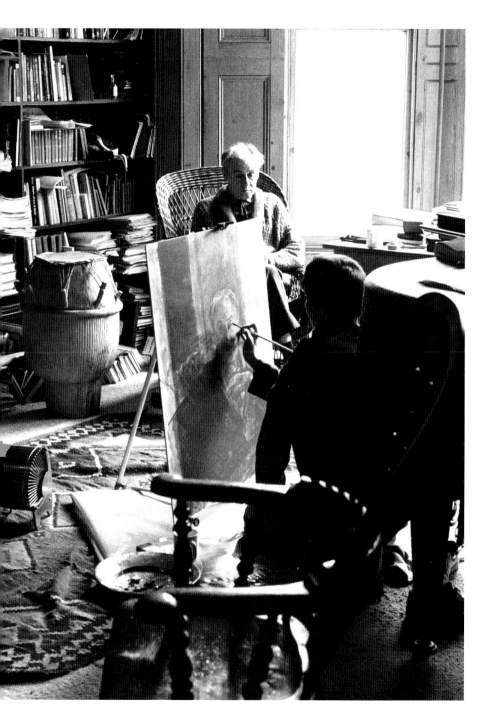

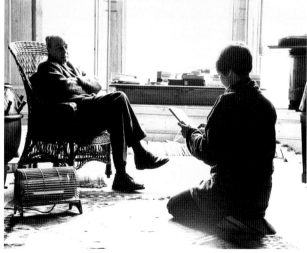

16 John McIntyre

1986 · oil on board · 142 × 116 cm
University of Edinburgh Art Collection; presented by the
Very Reverend Professor John McIntyre, 1987

I was asked to paint John McIntyre, Professor of Divinity at Edinburgh University and recent Moderator of the Church of Scotland, in the early '80s. I was very interested in the theology of the '70s and '80s. My Catholic upbringing had left me looking for a new philosophical stance, a greater understanding of existence, which even after leaving the Church, was very important to me. Books such as Bishop John A.T. Robinson's *Honest to God* and the multi-author *The Myth of God Incarnate* produced media debate about the place of Christianity in a secularised, evolutionary world view. I'd been trying to read Pierre Teilhard de Chardin as well as Paul Tillich, and Don Cuppit's *The Debate about Christ*, so I welcomed the chance to work with Professor McIntyre and looked forward to talking with him.

I met him and his wife Jan at their house in Minto Street, and was then taken around New College with that huge declamatory statue of John Knox in the entrance. During the visit I saw the Senate Room where the portrait would hang, and I was delighted to see a portrait there by James Cowie with fields and sky behind the sitter, among the overall dark solemnity. I was looking for an environment in which to paint John and some vision of how to place him. This was proving difficult, as I was trying to envisage how to express his profound intellect and spirituality when what I was seeing was a quiet, conservatively dressed man in a grey suit – thoughtful, polite and considerate. The painting would

have to hold position visually with all the other Senate Room portraits … and to be able to cope with Knox outside! John McIntyre was at that time a Knight of the Order of the Thistle, and when I saw the robes, I began to get an idea of how I could express his inner intellectual strength, faith and commitment within his unassuming persona.

I had seen the Douglas Strachan stained-glass windows in New College, with their very powerful and unusual mythic imagery, and began thinking of the contrast of passivity and movement, of containment and fiery expression. One painting I had long admired in the National Gallery in London when I was a student was the Hieronymus Bosch *Mocking of Christ*. There was a predominance of metallic surfaces and spikes, bright colour, exaggerated expression and personifications of evil and cruelty among the group surrounding the central figure of Christ who was totally passive, dressed in white, with pale skin and an unemotional direct gaze at the viewer. Despite these contrasts, one's eye came back again and again to the passive acceptance of the central figure. I began to see a way to paint John. I asked him to wear the brilliant-red cassock and the deep-green satin Thistle robes. The background became a quote from the Strachan windows showing the eternal battle of good and evil between the devil and the angels – another red/green colour contrast, a movement of power and aggression. The face is quite pale, yet dominates, the gaze alert and direct, hands low and clasped. John stood throughout all of

the portrait sittings – the only one of my sitters ever to do so.

The painting had its final sitting at Monksview, Kittleyknowe with lunch planned for John and the family. It was brought to an abrupt end by Mike having to take me to hospital with biliary colic, while John stayed and looked after the children.

THE VERY REVEREND PROFESSOR JOHN MCINTYRE (1916–2005)
Theologian and churchman. Professor of Divinity at the University of Edinburgh for thirty years and Moderator of the General Assembly of the Church of Scotland during Pope John Paul II's visit to Scotland in 1982. Known for writing *St Anselm and his Critics* (1954).

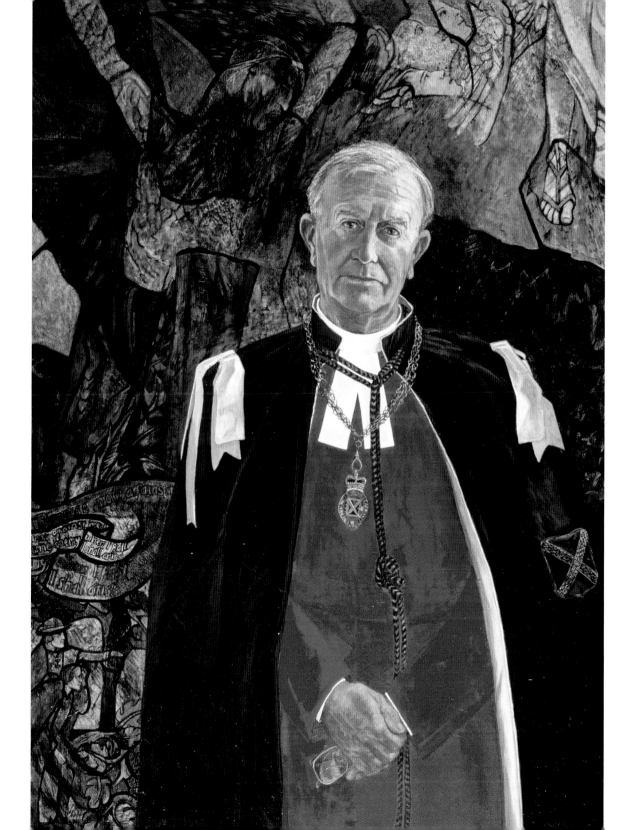

17 Lady Emma Tennant

1996 · oil on board · 32 × 80 cm
Chatsworth House (Duke of Devonshire collection)

I had an unexpected commission to paint lady Emma Tennant from her brother, the then Marquess of Hartington, the future Duke of Devonshire. Emma lived on a working hill-farm estate further down in the Borders … my daughter, Gemma, told me she was the mother of the model Stella Tennant. The connections between Chatsworth, Herdwick sheep and supermodels was intriguing. I was also very in need of this kind of challenge as Mike and I were still reeling from the loss of Ben and the trauma of the previous year. I set out rather unwisely in a fragile state on a January day thick with snow, to drive down to her isolated home.

The journey was one of remote areas of forested land, deserted roads, very few buildings and constant, though wet, snow. The world was a very unreal place for me at that time, a surreal winter journey that seemed endless. Suddenly a huge vehicle came thundering round the corner on my side of the road. The driver managed to swing out and avoid a head-on collision and to my horror I realised that it was I who was obliviously driving on the wrong side. The realisation was a nightmare. However, within ten minutes I had reached the farm. What a relief to sit in that kitchen with a warm and spirited woman, eating home-produced mutton, and talking of earth and sheep and gardens. I was very shaken by that experience and it wasn't until the early spring that I went down again, this time with Mike to stay for the four days of painting.

I became very fond of Emma and that intense first meeting stayed with me. She is shown in the painting against a reflection of the farmland with the recently restored drystone sheep pens. The frame of the mirror was an example of her daughter Issy's gilding. Emma is wearing a working sweater (out at the elbows) but with a beautiful Georgina von Etzdorf scarf which her supermodel daughter had bought her. I love the way that I could talk to her of country things – of blizzards and mole catchers, rag rugs in the local Women's Institute and sheep breeds. Emma painted watercolours of the fruit and flowers and vegetables she grew and had the most impressive botanical knowledge combined with an historical perspective of plants and great collectors.

Of course I was aware that my sitter was the daughter of 'Debo' Devonshire and came from great privilege and wealth. There was a striking Devonshire likeness around her eyes, and she told me and with pleasure of having run through the seemingly endless deserted corridors of Chatsworth with her siblings as a child. I very much enjoyed the juxtaposition of these aspects of her life. Nearly twenty years later, Emma and Toby donated fleeces from their flock to be spun and woven into the *Large Tree Group* tapestry, made from undyed wool and now in the National Museum of Scotland. The portrait hangs in the Duke's collection at Chatsworth.

LADY EMMA TENNANT (B.1943)
Daughter of 11th Duke of Devonshire. Chairman of the National Trust Gardens Advisory Panel; botanical artist.

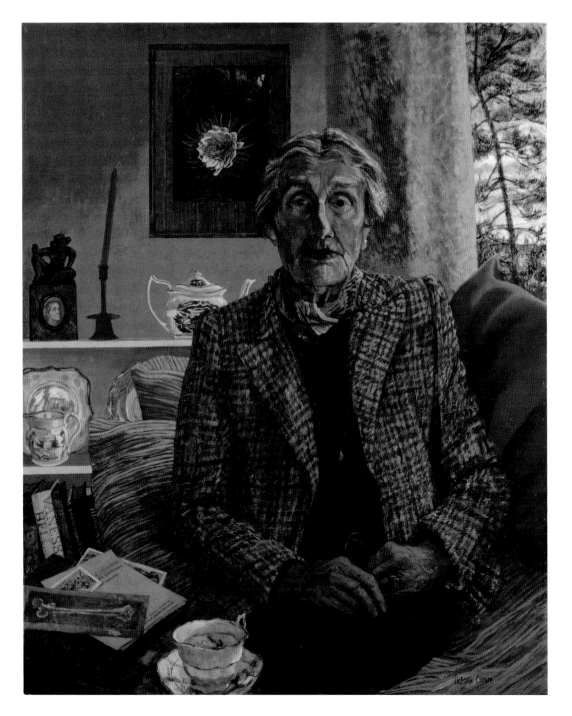

18 Janet Vaughan

1986–87 · oil on board · 112 × 84 cm
National Portrait Gallery, London

Dame Janet Vaughan had been Principal of
Somerville College, Oxford, 1945–67, a well-
loved figurehead. Janet chose to be a physician
in the belief that it would equip her for 'the
good fight' against poverty and social injustice.

Mike and I had been fascinated by a
television programme, *Women of our Century*, in
which Polly Toynbee had interviewed Dame
Janet about her extraordinary life. An eminent
scientist of 'blood and bones', her great
standing in the world of medicine ran parallel
to her political activities (she is featured in
the book of fifty women who did the most for
social change) and to her family life, involving
the Bloomsbury Group of Virginia Woolf
and her circle. She talked about the Spanish
Civil War, blood banks, her cure for anaemia
and being part of the first medical team into
Belsen. Visually she was so interesting – steely
grey hair pulled back, a tweed sports jacket,
silk scarf and a gash of red lipstick. I watched
entranced and wished that I knew her.

About two days later I was talking to a
friend, marvelling at this amazing woman
I had seen on TV, her fascinating life and how
I would like to paint her. The response was
'Oh you mean Auntie Janet?' As a result of this
extraordinary coincidence, my friend wrote to
her aunt in Oxford, who agreed to be painted,
and so I set off with boards, brushes and
easel by train from Edinburgh, very excited
and somewhat daunted to be meeting such a
powerful woman.

Janet must have been eighty-seven when
I painted her. She came roaring up to the

19 Janet Vaughan

1986–87 · watercolour and acrylic study
40 × 33 cm
Collection of Mary Park

station in her mustard-yellow mini, scarf on her hair. We had a slight problem loading my tubular easel, materials and her tubular walking stick into the back of the mini, but eventually set off for the Woodstock road. Janet was quite deaf and wore hearing aids which buzzed and whistled because of the scarf. She couldn't always hear when the gears needed changing, and so our journey was full of whines and crashing gears, as we sped through Oxford.

I had seen a portrait of Janet when Principal of Somerville, by Claude Rogers, showing a more physically robust, younger person than the woman I was confronted with. The lipstick reminded me of the sort of thing my mother wore when I was a child – something like 'cherry red'. Her makeup was a rather orange shade of panstick.

The next day we started the sittings in her drawing room surrounded by a lifetime's collection of artefacts and memorabilia. She had a virtually complete set of prints from Thornton's *The Temple of Flora* around the rooms. I loved the surreal quality of those images and the way in which landscape was juxtaposed with the plant in question. One print from that series, *The Night-Blooming Cereus*, was a first indication, I suppose, of the reoccurrence of dramatically opposed elements within Janet's life – the innovative medical scientist with a family background of arts and literature; research notes side by side with the pretty china, inherited from her mother; involvement with the Bloomsbury Group; her experimental and innovative treatment

for anaemia using liver extract, which was first liquidised in Virginia Woolf's mincing machine; the daughter of a wealthy establishment family standing on the beach with the anti-fascists in war-torn Spain; the determined socialist from a background of privilege; her sense of pride in becoming a Fellow of the Royal Society. In that art-filled drawing room all these contrasting elements seemed so relevant to the physical being of the sitter.

We talked long about her life as I painted. While the larger oil was getting established I started an acrylic and watercolour study of Janet. We talked about her war work and the setting up of blood banks, and during that sitting she told me of her entry into Belsen with the first medical team in 1945. A living witness to that horror … history unfolded itself before me. She told me of the concentrated formulation to rehydrate and nourish the camp's surviving inmates, of trying to find something to flavour the 'foul stuff' with. When the concentrate had to be injected into some of the survivors, they fought and cried 'nicht crematorium' – some of their fellows having been injected with paraffin before death. As I painted that image of Janet, her words were burnt into my mind. When I look at the painting now I still hear them. This experience fed into the larger portrait, together with knowledge of her many outstanding achievements and her privileged background, but the eyes I met with would always be the eyes that saw Belsen.

We used to sit and drink gin in the

evenings. I had heard Janet described as formidable and domineering, and she certainly had a wonderful 'plummy' voice; however, I had met her in old age and had the opportunity to listen. When I finished the portrait, her comment was: 'You have seen in me something that many have missed.'

DAME JANET MARIA VAUGHAN
(1899–1993)
Haematologist and radiation pathologist. Researched diseases of the blood, blood transfusion, the treatment of starvation, and latterly studied the effect of radioactivity on the bone and bone marrow. Principal of Somerville College, Oxford 1945–67.

20 Tam Dalyell

1987 · oil on board · 120 × 100 cm
West Lothian Council

I painted Tam Dalyell at the Binns, the family home given over by his mother to the care of the National Trust for Scotland in 1946. This commission was a celebration of his twenty-five years in parliament and the painting is very much about the man and his long association with the area he represented. I stayed at the Binns for the week of the portrait sittings and was able to get to know more about Tam, his wife Kathleen and their children. I was sleeping in one of those bedrooms with the ornate plasterwork ceilings which hang down almost like stalactites gleaming pale in the night … an unnerving place to sleep the night before the start of sittings!

We chose to work in an upper room with views out over the local hamlet of Mannerston Holdings, and across the Forth towards the industrial area around Rosyth in Fife. The window was behind Tam and to his right, which gave me some real problems in terms of the light on the rest of the painting, but it seemed to underline the inner and outer life of the sitter – the simple dark constancy of the figure against the overspill of light on his research and writings and the real world beyond. I wanted to convey the characteristics of tenacity, adherence to a personal truth and erudition which I perceived in his political life. Originally Tam was determined to stand throughout the painting, but after about an hour of swaying and twisting and looking out of the window, we compromised with a high stool. He was a little late one morning with telephone calls from London, and as he

52

21 Tam and Kathleen Dalyell

1988 · oil on board · 110 × 120 cm
Collection of Kathleen Dalyell

came thundering up the spiral staircase for the sitting, he suddenly let out an almighty shout for Kathleen. He had been stung by a wasp and had to receive medical treatment. Hidden somewhere in the painting is a wasp.

Tam and I talked about politics, of course, and several of his books in the painting refer to the time of the Falklands war, the sinking of the *Belgrano* and his abiding criticism of Margaret Thatcher. He was very loyal to his mentor Richard Crossman, a volume of whose *Diaries of a Cabinet Minister* is on the table with the *New Scientist* magazine for which Tam regularly wrote. I liked the simplicity of the grey tweed jacket he wore, but the Labour Party tie was made out of material which always looks as if it has had coffee spilt down it.

Kathleen Dalyell was a wonderful help to me. Tam did not do chat; his conversation was always deliberate, considered, and he didn't talk unless he had something of great import to say. For me, Kathleen was a kind of interpreter, a go-between, talking around the subject of her husband and his work, and I felt her constant support and rare intelligence made a balance for Tam between family life and the complex world of politics. In the double portrait I later painted for the Binns, this dynamic between them is very apparent. Tam languorously takes a back seat while Kathleen is much to the fore, well-lit and focused (she's winning the game of chess they are playing). The great Waterford glass mirror behind reflects them, the children, the dog, possessions and the warm feeling of the Binns. I felt a deep affection for both of them.

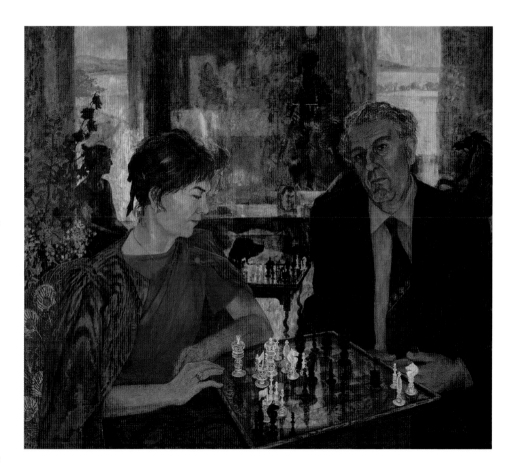

SIR THOMAS DALYELL OF THE BINNS, 11TH BARONET (1932–2017)
Scottish Labour Party politician. Member of the House of Commons from 1962 to 2005, Scotland's longest-serving MP. Opposed to Scottish devolution, he became known for posing the 'West Lothian question'.

KATHLEEN MARY AGNES DALYELL (B.1937)
Member of the Historic Buildings Council for Scotland. Served as Chair of the Royal Commission on Ancient and Historical Monuments and Director of the Heritage Education Trust. Awarded an OBE in 2005.

22 The Earl of Wemyss and March

1989 · oil on board · 96 × 111 cm
National Trust for Scotland, Edinburgh

The portrait of Lord Wemyss was commissioned by the National Trust for Scotland. The sittings took place at Lord Wemyss's home at Gosford, East Lothian, which was absolutely huge; he had a model of the whole house in one of the rooms, colour-coded showing where the dry rot had spread to, where fire had destroyed part of the interior and the remaining wing which he lived in. That area was big enough, with the wonderful pink-and-white marble hall with its balcony above lined with paintings (the Botticelli 'Nativity'[1] which is now in the National Gallery of Scotland was there at the time). David Wemyss had a library downstairs off the marble hall – a relatively small room with views back along the coast to Edinburgh and the most beautiful wall of leather-bound volumes, shiny rubbed gold lettering, worn spines, a textural panel of history and connections. It was here that we decided to work, as the setting allowed me enough freedom to incorporate many of the anomalies of the house.

The door from the normal-sized study opens onto a small corridor hung with Italian paintings, one of which is included in the portrait. Beyond the corridor, the space opened up into the vast double-height marble hall: it was one of those Alice in Wonderland transitions of proportion. Lord Wemyss was quite deaf when I was painting him, so that gulf of experience between us was lessened by the tours around Gosford that he took me and Mike on, often accompanied by a bucket of wet cement so he could patch up the odd bit of crumbling wall

as we walked. One part of the house had been destroyed by fire when occupied by British soldiers billeted there during the Second World War. We stood on the edge of this huge void of blackened walls several storeys high, before shutting the connecting door and returning to normal reality. He had a full bound set of Piranesi etchings which he showed me, and which echoed the feeling of the house. One thing I discovered to my delight was that his favourite jacket which he wore most of the time (and is in the portrait) was bought by his late wife from an Oxfam shop. So the portrait became about the juxtaposition of the practical wall-patching man in the charity-shop jacket surrounded by the different story that the possessions and setting told. His deafness was in many ways a felicitous attribute: it's the slightly questioning look, a bit unsure – 'What was it you said?' – that I think gave the portrait such a sympathetic feel. By the end of the painting I think we had established a warm affection for one another.

FRANCIS DAVID CHARTERIS, 12TH EARL OF WEMYSS AND 8TH EARL OF MARCH (1912–2008)
Scottish peer, landowner and conservationist. From 1949 to 1984 he served as Chairman for the Royal Commission on the Ancient and Historical Monuments of Scotland; from 1946 to 1991, as chairman of the board and then president of the National Trust for Scotland; and as a member of the Royal Commisson on Historical Manuscripts from 1975 to 1988.

my window
primar
figure
desk top

3 aspects to comp. Starting with fig in study premises,
reference to NTS (documentation / interest in architecture)
view to Edinburgh using upstairs view.
Introduce mirror so as to use marble hall glimpsed
through door-way
Also Piranesi Bath of Rome one of Lou's favourite objects
this will refer to classical architecture etc.

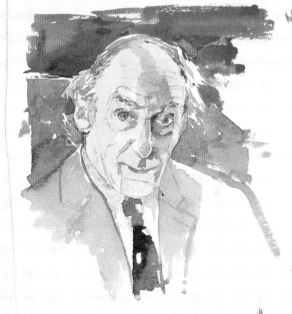

ref to marbled hall via mirror reflection

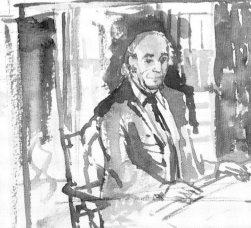

view on Lou's eye level
of Edinburgh

POS.
profile.
horiz line on skyset
silhouetted fig
at desk seen
over
collection
ornaments
repaired statuary
milk bottles (old)
letters
Gosford pamphlets
NTS publications etc

Piranesi
etchings of Rome

Study +
Desk
window
frame

poss. use reference to marble hall
via mirror + open door-way

show top of door-way to

too formal, too much around to centre

Watercolour

23 Preparatory compositional studies

1989 · pencil and watercolour · 45 × 50 cm
Collection of the artist

24 Study of library and documents

1989 · watercolour study with pencil · 29 × 27.5 cm
Collection of the artist

25 Study of library and documents

1989 · watercolour study with pencil · 32 × 33 cm
Collection of the artist

26 Jean Keeling

1990 · oil on board · 137 × 120 cm
Private collection

I met Jean Keeling in Edinburgh after Professor Eric Walker had contacted me to see if I would paint her. When I don't know a sitter very well I always have a research meeting to find out a little about their life and work and attitude and to check out the chemistry. I explain how I like to arrange the sittings, usually on consecutive mornings over four to five days.

Jean was impressive and I liked her immediately. She was at that time a world-class paediatric and perinatal pathologist; she worked at the John Radcliffe Hospital in Oxford and at the Hospital for Sick Children (SickKids) in Edinburgh. She was a respected expert witness in cases of child mortality and she researched pre-birth conditions and cot deaths. Jean was an attractive, dynamic woman who loved jewellery and clothes and occasionally power dressed to her advantage. The table in the painting is covered with cuttings, research, post-it notes, books and cards and bits of art. Jean was an energetic personality: she enthused over travel, cooking, anthropology, art, botanical gardens and – her hobby at the time – upholstery. This hugely professional woman within her field of pathology and law and related medicine had a palpable enjoyment of other aspects of life. I endeavoured in the portrait to point to some of these: as she looks up from the medical reference book, the colour supplement of lamb stuffed with rosemary slips to one side, and in the background is a chair undergoing one of Jean's reupholsterings, with specialist twine and wicked curved needles to stitch up and finish the job.

We have remained close friends since that portrait. Jean and Eric, who was a pathologist at Aberdeen University during our son's career there, were the people who guided us through the results of Ben's biopsy. Jean had power-dressed conspicuously when we were trying to access GP notes concerning the delay in referral, and she remained as a medical advisor on the Ben Walton Trust, a charity which Mike set up and ran for twenty years to raise awareness and research into oral cancer in the young.

Some of the conversations we had at the time of the portrait were intriguing. Jean was particularly instrumental in having the Phoebe Anna Traquair frescoes in the children's mortuary at the SickKids restored, valued and cared for. We walked through the Scottish National Galleries on one occasion looking at paintings of the Nativity, and Jean indicated which representations of the baby Jesus were painted referencing stillborn or dead children because of certain anatomical anomalies. I had never thought of those paintings in that way, an extraordinary new perspective. A powerful lady indeed.

DR JEAN W. KEELING (B.1940) Consultant paediatric pathologist at the John Radcliffe Hospital, Oxford and then at Edinburgh's Royal Hospital for Sick Children (now SickKids) for over thirty years. Author and editor of *Fetal and Neonatal Pathology* (1987), a classic reference book now in its fourth edition. Keeling, now retired, regularly volunteers at the Herbarium at the Royal Botanic Garden, Edinburgh.

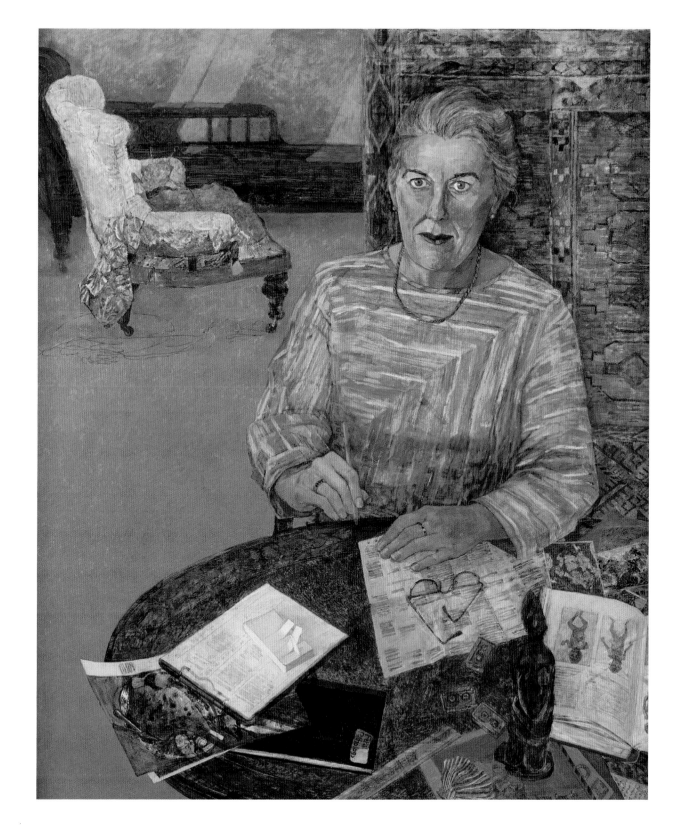

27 Heroes and Villains 1991 (Portrait of Ben)

1991 · oil on board · 76 × 109 cm
Collection of the artist's family

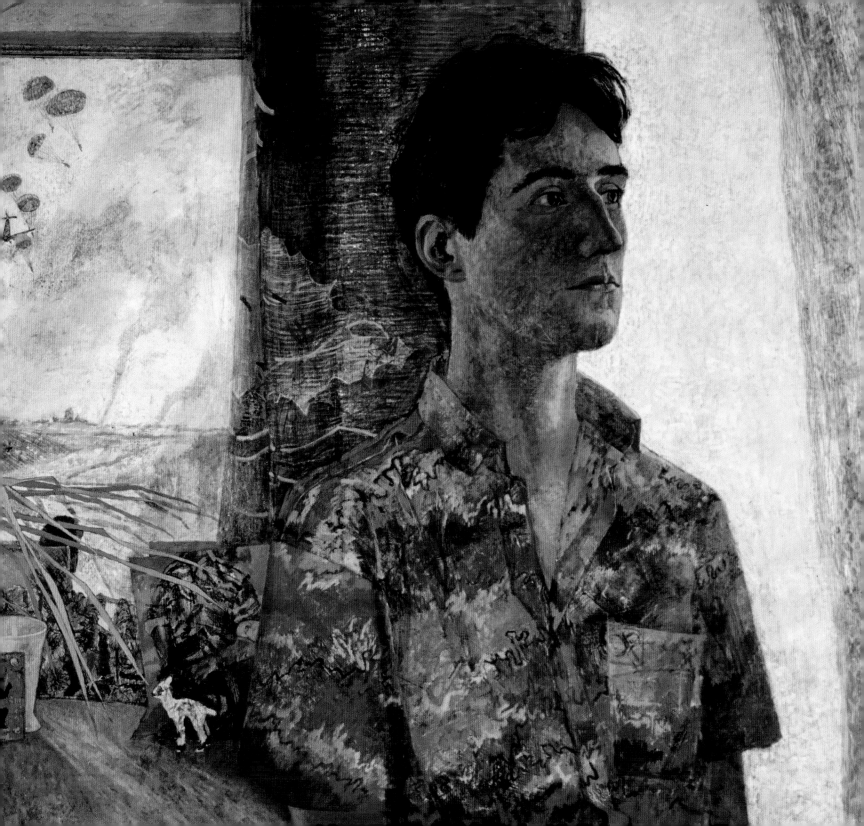

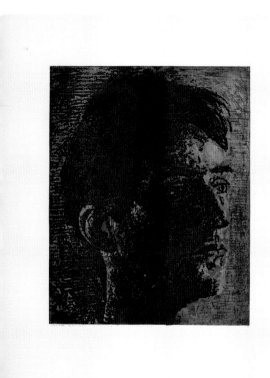

28 Ben Walton

c.1996 · etching with mixed media · 34 × 25 cm
Collection of the artist's family

29 Drawing of Ben in Profile

February 1995 · pencil · 35 × 50 cm
Collection of the artist's family

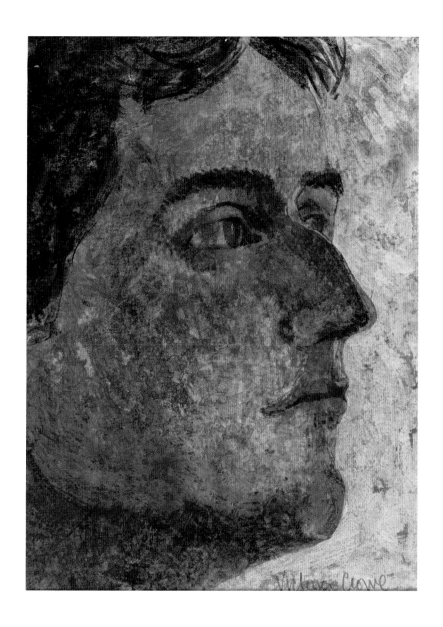

30 Study of Ben

1991 · acrylic · 18 × 13 cm
Collection of the artist's family

31 Duncan Thomson

1995 · oil on board · 45.5 × 35.5 cm
Private collection

I painted Duncan in the summer of 1995 at my studio in West Linton. It was an unbearably hot few days, the air from the open window making the light-deflecting blinds bang and clatter. I had met Duncan in his role as director of the Scottish National Portrait Gallery in 1982, when he bought my painting of Winifred Rushforth for the collection. He was instrumental in building up the fine collection of twentieth-century Scottish portraits from painters, such as myself, who were not 'portrait painters'. He had guided me through the R.D. Laing commission process in 1984. We had become friends with Duncan, his wife Julia and their daughter Becky, who was close in age to our two children, Ben and Gemma, and we often met socially.

The summer of 1995 was an awful time for our family; Ben's cancer, diagnosed the previous year, had become terminal, and we had an unknown number of months to live as 'normally' as possible, while awaiting the inevitable. Ben had been very ill in St Columba's Hospice at that time, but had stabilised enough to go back up to Aberdeen for his girlfriend's graduation. Gemma was spending part of her university vacation in Japan, trying to build some perspective and normality into her life. Many acquaintances, parents of my son's friends in the village, simply could not talk to me about what was happening – a sort of primitive fear to keep their own young safe and not acknowledge such a thing was possible. Duncan was always fond of our children and he came out

in July that year to see us and talk of Ben. While talking, I began drawing him, and that led on to the idea of a small portrait head. The painting became a kind of meditation on the conversation we were sharing, and for me a way of getting through two more days. People have said he looks sad in the portrait … that's just how it was.

DR DUNCAN THOMSON (B.1934)
Keeper of the Scottish National Portrait Gallery, Edinburgh from 1982 to 1997. An authority on seventeenth-century British painting and the work of Sir Henry Raeburn; he curated the exhibition *The Art of Sir Henry Raeburn 1756–1823* held in Edinburgh at the RSA and at the National Portrait Gallery, London in 1997 and 1998.

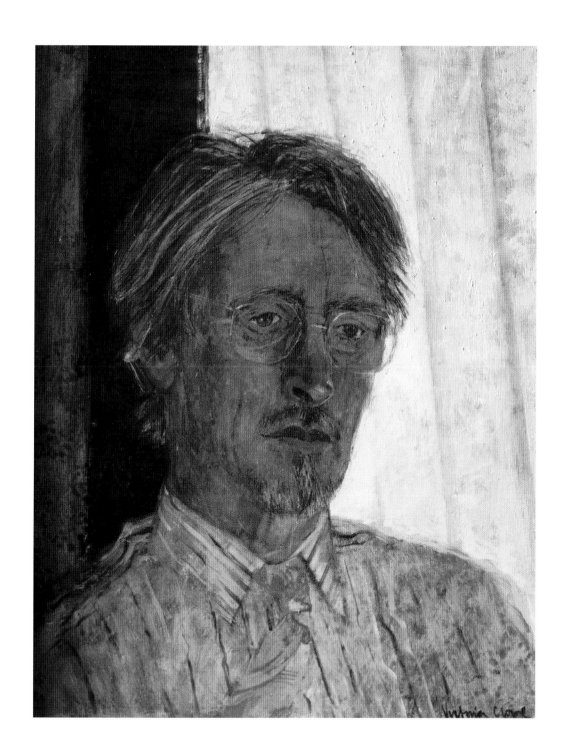

32 November Window Reflecting (Self-portrait)

1995–96 · oil on board · 140 × 160 cm
Private collection

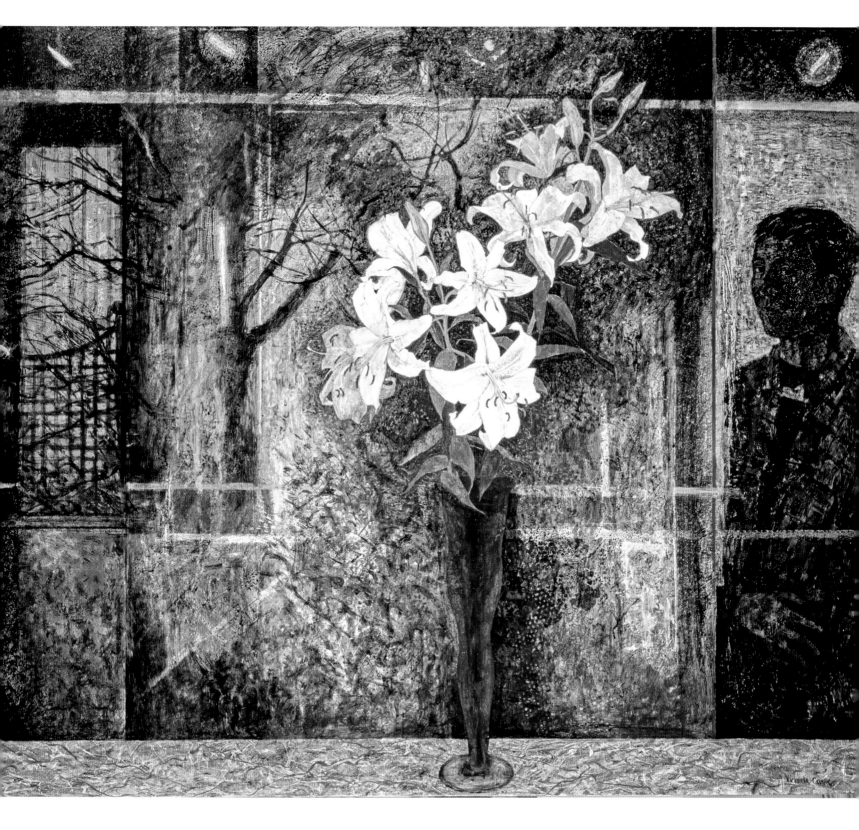

33 Graham Crowden

1996 · oil on board · 101.6 × 76.2 cm
Scottish National Portrait Gallery, Edinburgh;
gifted in memory of Ben Walton

As a family we had seen that wonderful actor Graham Crowden many times, in film and on TV and in the galleries around Edinburgh and London. When Ben was at home in January to February 1995, recovering from radiotherapy, one of his favourite things was to watch reruns of *A Very Peculiar Practice*, a cult TV series about the medical practice at the fictional Lowlands University. Head of the practice was Jock McCannon (played by Graham) – the Scottish doctor with a fondness for Glenfiddich whisky and a great line in clashing shirts and ties. His character speaks in the medical centre of 'daylong sittings with Ronnie Laing … transcendental meditation and the Tavistock clinic'. We loved the series and the characters within it. I had a show at The Scottish Gallery in November that year and we had heard that Graham had been in to see it. Ben was very excited – 'You must paint him, Mum!' A month later, Ben had died but I went on to fulfil that request. I met Graham and told him our story. What a warm and delightful man! We met again at his flat in Stockbridge, with his wife Phyllida, and thought about how I could best paint him. The flat was too small to work in, being full of paintings and family furniture, but had warm directional light from the window. The sittings were undertaken at a friend's studio in Leith, holding on to the central light source and warm feeling of his home. Graham was wearing a brilliant red shirt and braces (coincidentally in the manner of Jock McCannon) and he holds a National Theatre programme in his hand.

He was at that time rehearsing *Richard II* with Fiona Shaw, directed by Deborah Warner. (He bought them both designer jewellery from The Scottish Gallery to commemorate their working relationship.) We talked through most of the sittings of our families, of the paintings he collected and of his career. We remained great friends throughout the rest of his life. The portrait, which is full of the affection I felt for Graham, was donated to the Scottish National Portrait Gallery in memory of our son. During the presentation in the Great Hall at the portrait gallery, where our family and Graham's gathered, a clip from the TV series was played, bringing everything full circle.

Our affection for Graham and Phyllida has led to a continuing relationship between Phyllida and our family – including Gemma and our granddaughter Estella – since Graham's death.

GRAHAM CROWDEN (1922–2010)
Actor. An eminent member of the National Theatre, the Royal Shakespeare Company and the Royal Court, noted for acting the role of the Player King in Tom Stoppard's *Rosencrantz and Guildenstern Are Dead*. Became a household name when he appeared in the BBC's television sitcom *Waiting for God* (1990–94).

34 Callum Macdonald

1996 · oil on canvas · 68.5 × 88.9 cm
Scottish National Portrait Gallery, Edinburgh; purchased
with the assistance of Macdonald Lindsay Pindar plc 1996

By now, many of the portraits had begun to have shared links – experiences of music, literature or poetry. I was very interested when the printers Macdonald Lindsay Pindar asked me to paint Callum. He was a huge promoter of Scottish poetry publication, and when I met him he was producing the poetry magazine *Lines Review* and supporting the setting up of the poetry library with his second wife, Tessa Ransford. Callum loved poetry, and after the war he settled in Edinburgh and taught himself to print on a Heidelberg Automatic Platen printing press and began publishing and promoting it. He knew and worked with all the big names in Scottish poetry – Sorley MacLean, Hugh MacDiarmid, Sydney Goodsir Smith, Norman MacCaig and so on. What I really liked about him was his gentle, rather shy personality, a contrast with what one hears of this group of post-war Scottish poets. Here was the man described by the writer Angus Calder in an obituary in *The Independent* as 'A man of wide vision, not a Milne's Bar groupie. A reserved and dignified Gael.' Callum was deeply respected by his more rumbustious poet friends and he brought them to prominence.

The portrait was painted in Innerleithen in Callum's sitting room, darkened somewhat by the full-strength cigarettes he favoured – smoke from one of which can be seen spiralling up from the base of the painting. He is holding an open copy of *Lines Review*, its cover design echoed by the Venetian blind behind him which added to the soupy light in the room and revealed something of the rural landscape outside. There was a gentleness about the green flat tweed jacket, which was soft and immaculately cut. On the wall to the right is a reference to a framed picture which pulls together the world of his poets: it is a print given to Callum of a drawing of MacDiarmid made by Goodsir Smith and once owned by MacCaig.

I liked the idea of this thoughtful quiet man having been the catalyst for the regeneration of Scottish poetry. He spoke of his dreadful shyness and his reserve, but was a very generous man. He happily shared a bottle of 25-year-old malt whisky with my husband, but Tessa and I, being ladies, had to have sherry!

CALLUM MACDONALD (1912–1999)
Scottish literary publisher and founder of Macdonald Publishers and Printers. Managing Editor of the journal *Lines* (became *Lines Review,* 1952) specialising in Scottish poetry and was instrumental in advancing the work of many major Scottish poets such as Hugh MacDiarmid.

35 Ole Lippmann

1997 · oil on board · 91.2 × 101.2 cm
National History Museum, Frederiksborg Castle, Denmark

The Danish Museum of National History hosted an exhibition of *Five Hundred Years of Scottish Portraiture, 1595–1996*. The two national galleries had an exchange commission, whereby an artist from Scotland painted a Dane and vice versa. Thomas Kluge painted Rikki Fulton for the Scottish National Portrait Gallery and I was asked to paint Ole Lippmann for the national portrait collection at Frederiksborg Castle. My sitter was the resistance leader and head of the Special Operations Executive in Denmark during the Second World War.

I knew Denmark fairly well but had never been up to Skagen on the far northern tip – a low-lying sandy promontory with the most amazing light reflecting from the water, sand and shiny dune grasses. Two seas could be seen to meet at that furthest tip, and huge inland sandhills constantly changed shape and direction blown, grain by grain, by the wind. Ole lived in a traditional Danish farmhouse with his wife Inga, who trained horses. Danish country interiors are very beautiful … lots of painted wood, candles, simplicity and functionality. Draped translucent cotton curtains at the windows allowed the sunlight to play over the walls and floors. This charming interior was at odds with all I was beginning to discover about Ole Lippmann's war work.

Denmark was an occupied country, its small army easily overcome by the German forces. Lippmann became active in the Danish resistance, organising civil disobedience, strikes and sabotage. He was instrumental in providing safe passage for Jewish refugees to neutral Sweden: six thousand Danish Jews were able to escape. He became head of the SOE in Denmark, liaising with resistance groups throughout Europe, and working undercover. As a young man of twenty-seven, he was having to take the huge decision of asking RAF assistance in the bombing raid on Gestapo headquarters, the Shell House in Copenhagen, knowing the inevitable threat to civilians. While successful in destroying Nazi documentation on resistance groups, killing many Gestapo and, due to pinpoint accuracy, enabling many of the human shield of political prisoners to escape, there were, however, terrible consequences when one plane crashed sending up plumes of smoke, obliterating the target and leading to the accidental bombing of a school killing fifty-six children. Ole had to carry this responsibility all his life; when I was painting him, fifty-two years later, he was phoned up by a father of one of the children promising to one day avenge his daughter's death. Ole had received this phone call every year on the girl's birthday.

All this backstory was very important in painting the portrait. How could I put down so much that I felt about his work and how it had affected the man before me? – the bitterness of occupation, the hiding, constantly avoiding the Gestapo, unpalatable decisions at such a young age, the horror when innocents were killed, fear for family and friends. He was constantly on the move, never staying more than two nights in the same place and separated from Inga and the children. After the war Ole Lippmann returned to his business as CEO of a company selling medical instruments, but seemed able to turn up at hotspots throughout Europe, notably in Hungary after the 1956 uprising. I felt he remained something of a man of mystery, and now here he was in the beautiful Danish countryside, sitting before me.

The portrait shows him in a slightly military-cut shirt, short-sleeved, sitting against the pale wall in his house, casting a shadow on and around the surface behind him. His arms, resting crossed across his body, look very strong for such a slight man. Despite my growing understanding of his personal history and the enormity of that wartime experience, I felt there were many hidden aspects, someone moving in the shadows. The room by contrast is the lovely, simple, typically Danish farmhouse interior and an idyll of rural peace. Ole used to say that the real heroes of the Danish resistance were the farmers' wives who bravely and surreptitiously fed, protected and hid the refugees on the way to Sweden. I think his face holds great wisdom and strength, and some sorrow, the kind of sorrow one feels when one looks at the continuing folly of war. I felt great fondness towards Ole and Inga.

OLE LIPPMANN (1916–2002)
Leading figure of the Danish resistance movement during the German occupation of Denmark in the Second World War. Credited with enabling 6,000 Jews to escape from Sweden. Member of the wartime Danish Freedom Council.

36 Studies of windows relating to Ole Lippmann portrait

1997 · watercolour · 41.5 × 29.5 cm
Collection of the artist

37 Studies of windows relating to Ole Lippmann portrait

1997 · watercolour and pencil · 41.5 × 29.5 cm
Collection of the artist

38 Sketch of Ole Lippmann

1997 · acrylic and pencil on watercolour paper,
41.3 × 29.5 cm
Collection of the artist

39 Gemma

2000 · pencil · 59.4 × 42 cm
Collection of the artist's family

40 Portrait of a Young Woman, Milan

2000 · oil on canvas · 70 × 90 cm
Private collection

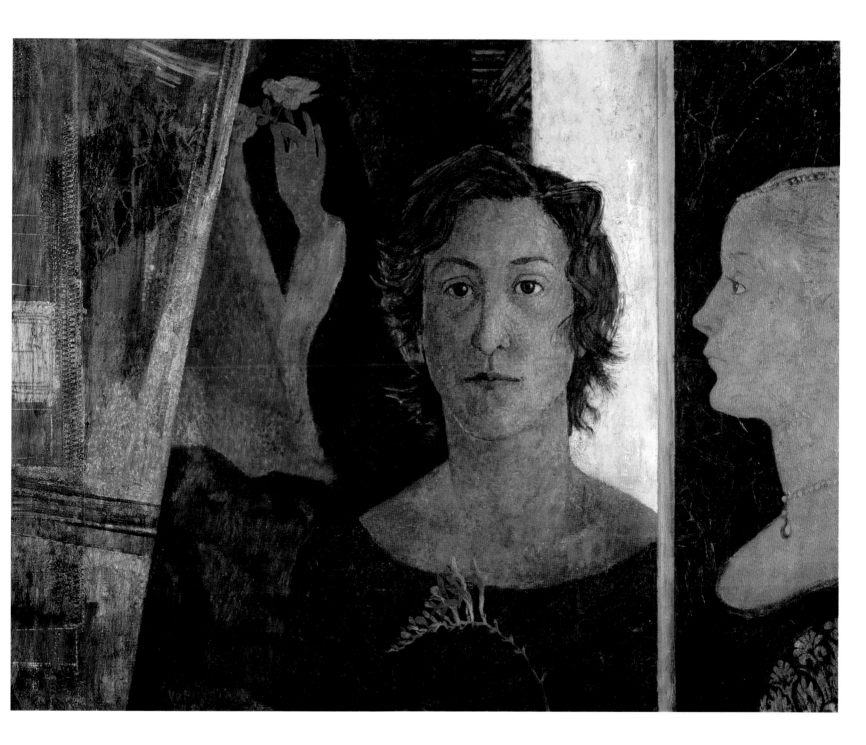

41 Self-portrait

2000–01 · pencil · 57.5 × 42 cm
Collection of the artist

42 Mirror of the South (Self-portrait)

2001 · oil on linen · 150 × 120 cm
Private collection

43 David Ingram

2003 · oil on linen · 150 × 120 cm
St Catharine's College, University of Cambridge

I very much enjoyed working with David Ingram while I was painting his portrait for St Catharine's College, Cambridge. David is a distinguished plant pathologist and had been Regius Keeper (Director) of the Edinburgh Royal Botanic Garden before his move to become Master at St Catharine's. Earlier meetings and the sittings themselves were filled with discussions around botany and plant form. Our shared enthusiasm ranged from the pathogens and scientific analysis of David's world to the visual depiction and historical references of mine, which provided a rich subtext to the portrait.

David was painted in the lodge at St Catharine's College. The large circle in the background was originally based on a window in the college (St Catharine was martyred on the wheel, and there are many references to circular forms in the building). However, as the painting and our conversation developed, it became more suggestive of the lens of a microscope upon which I could deploy images relevant to David's botanical research. The central image in the lens, of the yellow primrose with the smut pathogen, was included not only as a key image in David's publications but as a colour response to the purple of the pasque flower and the sitter's shirt, a perfect complementary colour. I felt that his Vivienne Westwood tie provided a slight edge to all the flowery naturalism!

The portrait marked a new phase of work for both of us. I went on to work with plant collections in herbaria and imagery in historical herbals which led to the exhibition *Plant Memory* at the Royal Scottish Academy some three years later. David has written, from his professional perspective, about the flower paintings of Henri Fantin-Latour, the flora of John Ruskin and the glass work of Émile Gallé as well as catalogue entries for artists and craftspeople.

PROFESSOR DAVID STANLEY INGRAM (B.1941)
Plant scientist: botanist and plant pathologist. Current scholarship includes synergy between botany/horticulture in nineteenth- and twentieth-century European arts and design. Honorary Professor of Science, Technology and Innovation Studies at the University of Edinburgh. Master of St Catharine's College, Cambridge 2000–07.

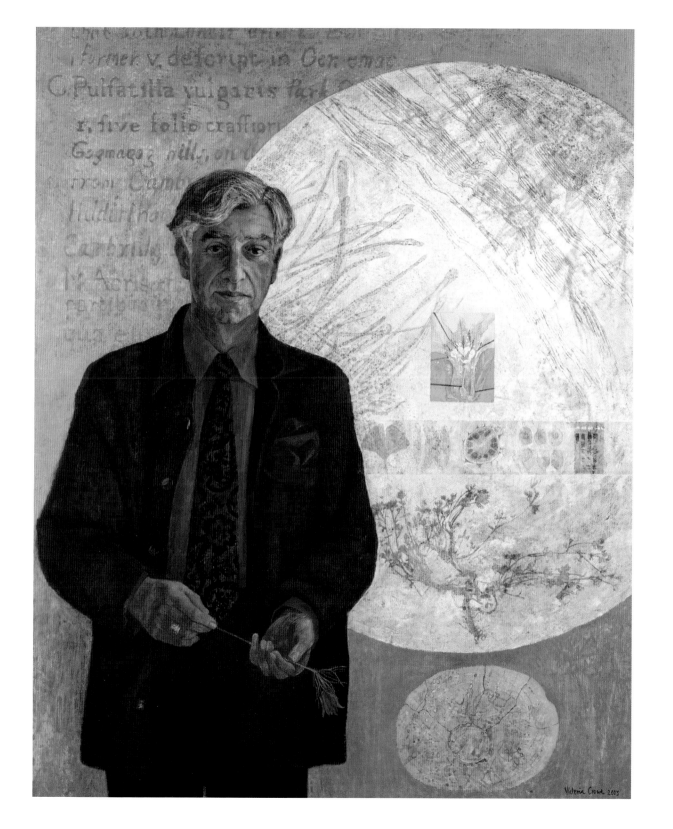

44 Thea Musgrave studies

2006 · watercolour and pencil · 35 × 81.5 cm
Collection of the artist

45 Thea Musgrave

2006 · oil on canvas · 76.5 × 91.5 cm
Scottish National Portrait Gallery, Edinburgh

I was commissioned to paint Thea Musgrave in 2004 for the Scottish National Portrait Gallery. Thea is a Scottish-American contemporary composer, and so I began to research her background and become familiar with her work. The first opportunity we had to meet was in London for a performance of *Turbulent Landscapes*, which was an orchestral piece based on some of Turner's paintings, each movement using a painting's title. As part of the pre-concert events, Thea was doing a masterclass with young musicians and Tom Service held an in-depth conversation with Thea about her work. This was particularly useful as I began to understand her involvement with the dynamics of the music, the soloists' role and her use of moving them around the orchestra during the performance to exploit the dramatic tension of the piece. This sense of drama extended to her scores, some forcefully underlined and full of stage direction explaining her love of composing opera. Thea had studied under Nadia Boulanger in Paris and afterwards worked in London. She became friends with George Steiner and Christopher Cornford in the Department of Humanities at the Royal College of Art, whom I would meet later in the Sixties when I was a postgraduate student there.

I painted the portrait in Norfolk, Virginia, where Thea lived with her husband Peter Mark, who was at that time Director of Virginia Opera. I spent the first day drawing her in her home and again at the opera house

in the evening. The Chrysler Museum very kindly gave us a gallery in which to work. It was full of classical statuary and, much to Thea's amusement, she was painted beside a sculpture of *Silence*, a female nude with a finger to her lips. As the week of sittings unfolded, so did an opera production that I watched in the evenings with Thea. I found the journey from singers in T-shirts and jeans, bare lighting, red and yellow tape on the floor to indicate positions, to full opera mode, fascinating. This development paralleled the growth of the portrait and fed the amalgam of images to the sitter's left. As both painting and opera grew in complexity I was able to see more of the musician's world … the huge stage-prop horse which figured in Thea's opera *Simón Bolívar*, the Chinese singers whom Peter and Thea worked with in Beijing and, most importantly, the conversation around the drama of her music.

I wanted the blue 'stage' space to echo her methodology: the animated score, the 2-D stage directions, the fascination with myth and powerful storyline which informed her work. One of the singers wrote the Chinese symbol for 'horse' (relating to Bolívar), which I felt visually indicated the fluidity of her music. I was

struck by the illusion created on the opera stage, watching a different reality emerge. To the far right in the painting is reference to a figure stepping into the auditorium from the lit corridor of the real world. This took me right back to conversations with R.D. Laing, about the Velázquez painting *Las Meninas* and illusionary space. The intrusion of this figure in the Virginia opera house seems to underline the real world and the imaginary world that we were seeing, making and talking about during the week of sittings.

Mike and I have met Thea and Peter many times since that week in Virginia. When the portrait was unveiled in Edinburgh, Thea attended and a performance of her music was given to mark the occasion.

THEA MUSGRAVE (B.1928)
Composer of opera, choral and classical music. Best known for her dramatic and communicative compositions such as *Turbulent Landscapes* (2003) and *The Seasons* (1988; based on paintings by J.M.W. Turner). In 2014, honouring sixty years of work, the BBC presented *Total Immersion: Thea Musgrave*, performed and recorded at the Barbican.

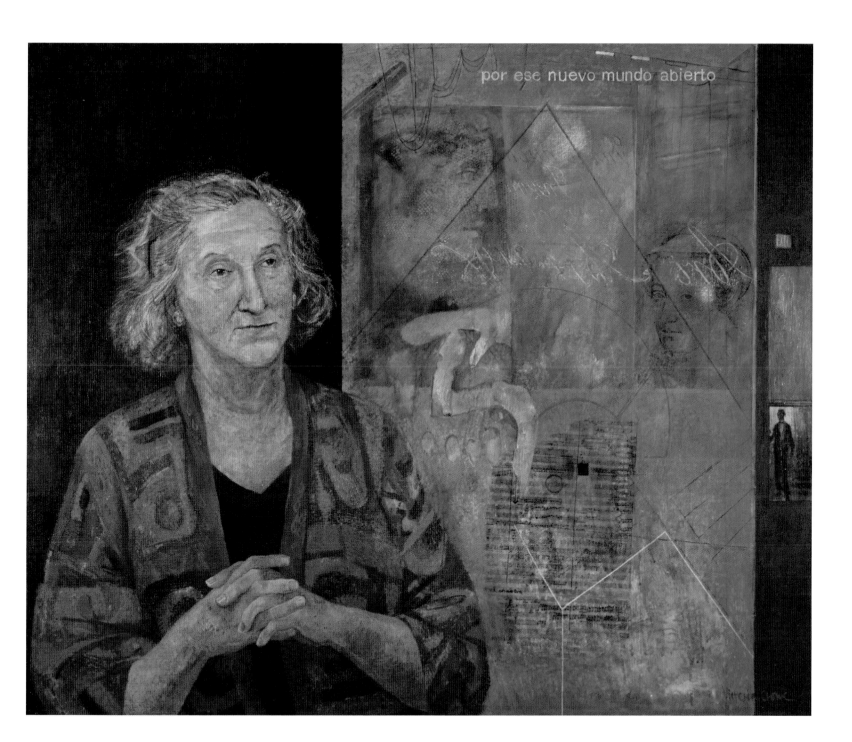

46 Ann Matheson

2009 · oil on linen · 90 × 103 cm
University of Edinburgh Art Collection

I very much enjoyed working with Ann Matheson. When I first met her, she was just retiring from the role of Secretary General at Edinburgh University. Her academic work included the role of Keeper of Printed Books in the National Library of Scotland.

She was visually interesting to paint as she had a very distinctive face, a fairness of skin and hair and a natural grace combined with a penetrating intellect. A native Gaelic speaker, Ann's childhood was spent in Conchra in the remote western Highlands where she attended the local school. She has a deep knowledge of Scottish history and culture, coupled with and enriched through her academic work, within a completely international context.

She has a love of printed books: their tactile qualities, the bindings, typefaces and lettering. She brought a selection of small early books from her own collection to the studio for me to see … they just fitted into the palm of my hand and were redolent of knowledge, beautifully presented and preserved, valued and treasured.

There was a clarity about her, of intellect certainly, but also of containment and composure. I remarked on the pose and posture: she sat for the portrait without any sort of backrest and claimed that was a result of great deportment lessons from primary schooldays, arms folded behind your back! The delicacy of her jewellery, her high-necked collars, the longish skirt and that incredible composure lent a calm and certainty to the portrait.

To the right of the figure, I used the engraved glass panels in the National Library of Scotland to contain references to aspects of her life and work; from the first printed map of Scotland showing the village she grew up in, through to the website and logos of current institutions that she was involved with. I tried to indicate the presence of her academic and administrative work within the Association of European Research Libraries, the Scottish Poetry Library, Sabhal Mòr Ostaig University of the Highlands and Islands and Edinburgh University. The texts and books referred to span from the earliest printed Scottish books to written text and twentieth-century concrete poetry.

While painting, I thought much about the duality of a Gaelic childhood in a small community in the western Highlands, and the wide outreach of her mature life with its international perspective.

DR ANN MATHESON (B.1948)
Librarian, historian, academic administrator, championed Scotland's literary and linguistic culture. Positions held include: Keeper of Printed Books at the National Library of Scotland; Secretary-General of the Ligue des Bibliothèques Européennes de Recherche (LIBER); and Chairman of the Advisory Committee of Sabhal Mòr Ostaig Library, University of the Highlands and Islands, Isle of Skye.

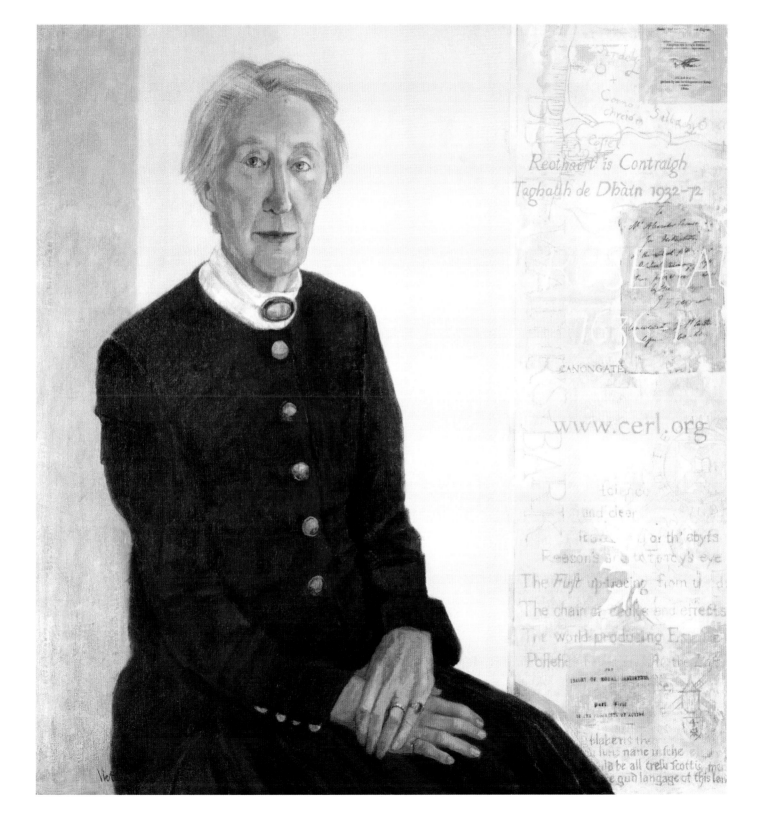

47 Studio Venice: Mirrored View

2011 · oil on linen · 120 × 147 cm
Private collection

My daughter Gemma has the most wonderful
Italianate profile and crops up in many of my
paintings. In this instance she animates the
richness, fragility and beauty of Venice and its
associations.

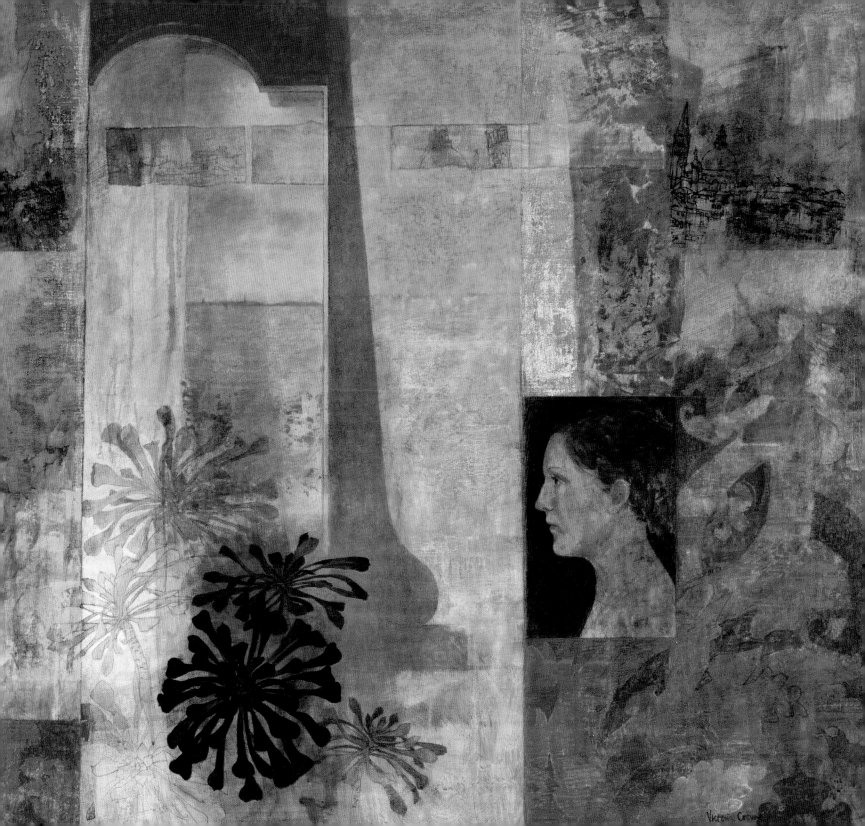

48 Peter Higgs

2013 · oil on linen · 140 × 130 cm
Royal Society of Edinburgh

I couldn't begin to have understood Peter and his Nobel Prize-winning work, but I was fascinated by the man. This giant of the world of Physics and I first met at one of my exhibitions at The Scottish Gallery before the first of many lunches that we continue to share. I had been asked to paint Peter for the Royal Society of Edinburgh and had seen the dramatic Ken Currie painting of him that hangs in the Physics department of Edinburgh University. Peter had been painted many times, but my work focused on the modest man sitting in his house, containing within him extraordinary world-changing potential.

I was very taken with a paper-shaded lamp which he had swinging over his reading chair: it had a floating spaceship feel to it, lit from within. The drab olive walls made a great period background, somehow fixing events to a time – the late '60s – when Peter had actually predicted what would become known as the Higgs boson but had had to wait years for its proof. The Georgian astragals gave a logical grid to the light behind him. Peter himself had a collection of shirts, all identical in style, in various colours: blue, dark blue, grey, maroon. I chose the grey one (each seemed to come complete with the pen in the top pocket). One of the leather chairs in his room was a Wassily chair by Marcel Breuer, which I liked because of the four-square pose Peter took up within it. I thought of it as a Constructivist's puzzle chair, as it was difficult to draw – no parallels where you'd expected them as the seat was hung sloping backwards.

On the first morning Mike went to collect the chair, and to bring Peter to the studio. Peter and Mike decided to take the chair apart to more easily carry it down the stairway from Peter's top-floor flat. I nervously waited in the studio only to find, when they arrived, that they could not get it easily back together again. So half of my precious and nerve-wracking first sitting was taken up with Mike and Peter crawling about on the floor to reassemble it (highly amusing in retrospect)!

Peter was a good sitter. We listened to music, especially Bach, or often worked in comfortable silence. The coffee breaks and lunches (which Peter looked forward to with relish) were full of communication. Many people have said of Peter that, in spite of his intellect, great achievements and remarkable memory, he is a self-contained and modest man; I found this to be very true. For most of the sittings the portrait was of a man looking directly at the viewer, but in the last couple of sittings I made the eyes look down and it suddenly became Peter.

Of course I wanted to reference the explosion revealing the Higgs boson and had looked at many images of such an event. In the portrait it hangs (like the paper lampshade) above Peter's head, and against the wall the equation can be seen. Peter had written it out for me and I transcribed it in his hand as well as I could. I also made it very subtle to read in places – something to be worked at by the viewer. At the base of the figure stands a glass bowl made by Dawn

Douglas. It has the form of a supersymmetry diagram which Peter referred to when trying to explain, unsuccessfully, the physics to me. On the bowl's surface there is an image of the 'boson explosion'. It is something that Peter has in his flat and admires. I have a strong visual memory of him holding the bowl up to the light, his hand becoming a silhouette.

The time span of real sittings, even if only the course of a week, enables adjustments in understanding, nuances of expression and response. One such bonus, apart from the deflection of his gaze, was when the light hit the recently cleaned lenses of the glasses in Peter's hand and they refracted a rainbow. After the week of sittings I carried on with the other parts of the painting, the olive wall, the blueprint of CERN, the chair, which, although I had begun to wish I had not started it, in some ways in its complexity echoed the idea of understanding different realities.

The portrait was presented to the RSE in the summer of 2013. For the evening I borrowed Peter's T-shirt with his formulae written across the front, although regretfully I never managed to obtain one of my own.

PROFESSOR PETER WARE HIGGS (B.1929) Physicist. Professor of Theoretical Physics and Professor Emeritus, University of Edinburgh. Proposed the existence of a new particle, now known as the Higgs boson. Nobel Prize in Physics (with François Englert) 2013.

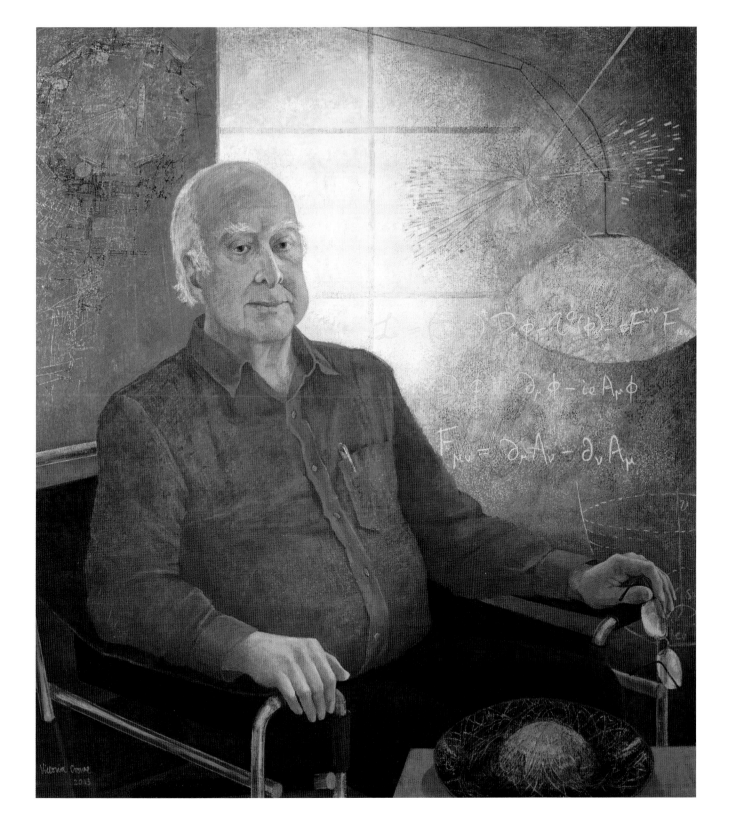

$$I = \left(\ \right) \partial_\mu \phi - n^2(\) \phi - \tfrac{1}{4} F^{\mu\nu} F$$

$$D_r \phi = \partial_r \phi - ie A_\mu \phi$$

$$F_{\mu\nu} = \partial_\mu A_\nu - \partial_\nu A_\mu$$

Victoria Crowe
2013

49 The Duke and Duchess of Buccleuch

2016 · oil on linen · 110 × 120 cm
Bowhill

Richard Buccleuch and his wife Elizabeth had been friends of ours for many years. They had collected my work since the Eighties and Richard had commissioned tapestry for his home in Boughton, Northamptonshire from the *A Shepherd's Life* series and had opened the exhibition when it was shown in London in 2009. I was delighted, though somewhat daunted, when Richard asked me if I would paint him and Elizabeth for their house Bowhill in the Scottish Borders. Two personalities contained in one painting is always a challenge, and I had to think carefully about the arrangement of this informal and very personal portrait.

I loved the beauty of the landscape around Bowhill, and, within the house, the visual richness of mirrors, gilding, fabrics, painted wallpaper, art and books. There is an amalgam of these references in the painting with a view out onto the lake in the mirror behind the couple. While I was there, a brilliant high-summer full moon flooded the gardens and surrounding landscape with light, casting long shadows of us over the grass. The layers and layers of history in a house like Bowhill, and indeed in the lives of the sitters, were somehow balanced by that heightened moon watching, bringing everything back to the present moment, while underlining the ephemeral nature of our existence.

Two recent events in the story of the house are referenced in the portrait: the restoration of the smoking room and its leather-bound volumes behind Richard, and the proposed restoration of the painted Chinese wallpaper behind Elizabeth. The wall covering in the painting refers to two surfaces – the distressed, worn silk brocade of the drawing room and library, transforming into the bird-and-flower-painted Chinese wallpaper from the former Duchess's room. We later saw this paper stripped of old glue, cleaned and then re-established.

These two events provided a natural male/female split in the double portrait, but the two figures are united by the ink-stained, well-used writing table, covered with a series of letters from the family archives which they were sorting through. Much conversation was around the annual prestigious Walter Scott Prize for Historical Fiction which was set up by the Buccleuchs in 2008. The books on the table are first-edition volumes of Walter Scott's work and a recent Prize-winning work, *The Garden of Evening Mists* by Tan Twan Eng.

The generosity of spirit and openness of the sitters made this a significant experience for all of us.

RICHARD WALTER JOHN MONTAGU DOUGLAS SCOTT, 10TH DUKE OF BUCCLEUCH AND 12TH DUKE OF QUEENSBERRY (B.1954)
Responsible for the overall management of his family's historic estate businesses, heritage properties and art collections including Drumlanrig Castle, Queensberry and Bowhill in Scotland and Boughton House in Northamptonshire. Closely involved in the wider heritage world as a Trustee of the National Heritage Memorial Fund and for ten years as President of the National Trust for Scotland. Currently a Trustee of The Royal Collection. Recently appointed High Steward of Westminster Abbey.

ELIZABETH MARIAN FRANCES (KERR) SCOTT, DUCHESS OF BUCCLEUCH AND QUEENSBERRY (B.1954)
Involved in cultural organisations as a former Chairman of Scottish Ballet, a Trustee of the National Museums Scotland and a Trustee of the British Museum. The Walter Scott Prize for Historical Fiction was founded by and is sponsored by the Duke and Duchess of Buccleuch; she has been a judge since its inception in 2009. In 2015 she founded the creative writing prize, the Young Walter Scott Prize.

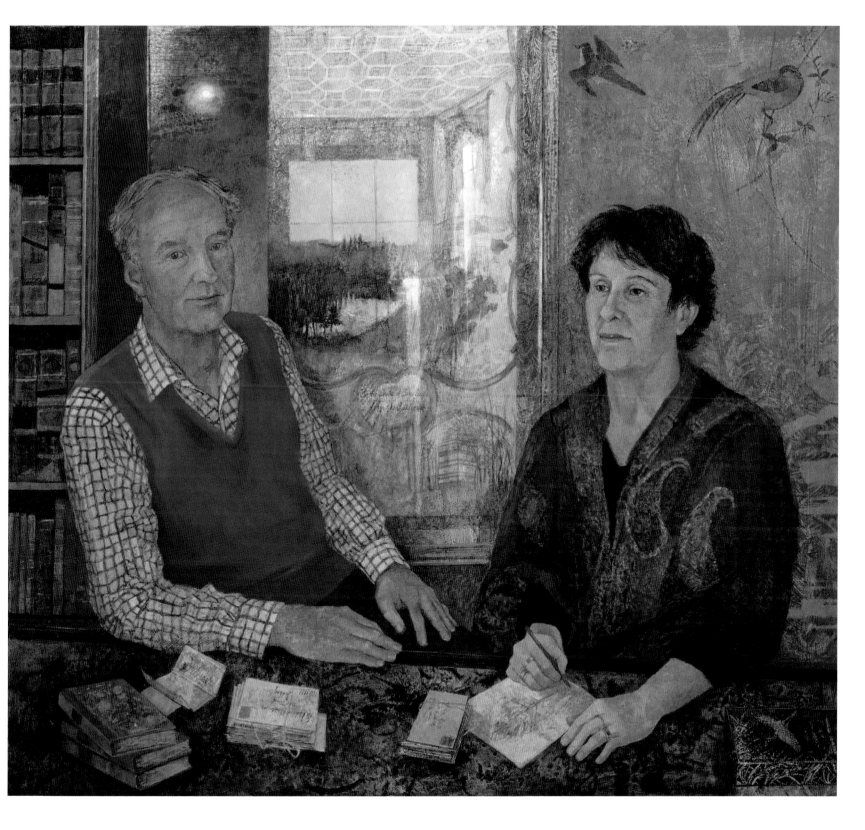

50 Jocelyn Bell Burnell

2015–16 · oil on board · 140 × 130 cm
Royal Society of Edinburgh

After painting Peter Higgs, the Royal Society of Edinburgh asked me to paint their new president, Jocelyn Bell Burnell. Her discipline is astronomy and she is passionate about encouraging more women into physics. As a secondary school pupil she had to fight to do science with the boys in her class, rather than domestic science which was offered to the girls. Likewise at Glasgow University she had to run the gauntlet of being the only female on her course. As a young Astrophysics researcher at Cambridge University, she was engaged in building the huge radio telescope and recording the data that it was receiving. Her meticulous attention to detail when checking the read-outs led to the discovery of an unexpected but regular burst of energy from a distant star … she had discovered pulsars. (The Nobel Prize went to her superior.) She has since had an illustrious career in astrophysics and is based at Oxford University. The painting shows her against the vastness of an imagined night sky with an image of a pulsar deep within the Crab Nebula. On her desk are the reams and reams of paper showing the electronic blips which she perused.

DAME (SUSAN) JOCELYN BELL BURNELL (B.1943)
Astrophysicist. As a research student at Cambridge University, helped to build and operate a large radio telescope and discovered pulsars. Conducted research in infrared astronomy at the Royal Observatory, Edinburgh. Received many awards, including Dame of the Order of the British Empire in 2007.

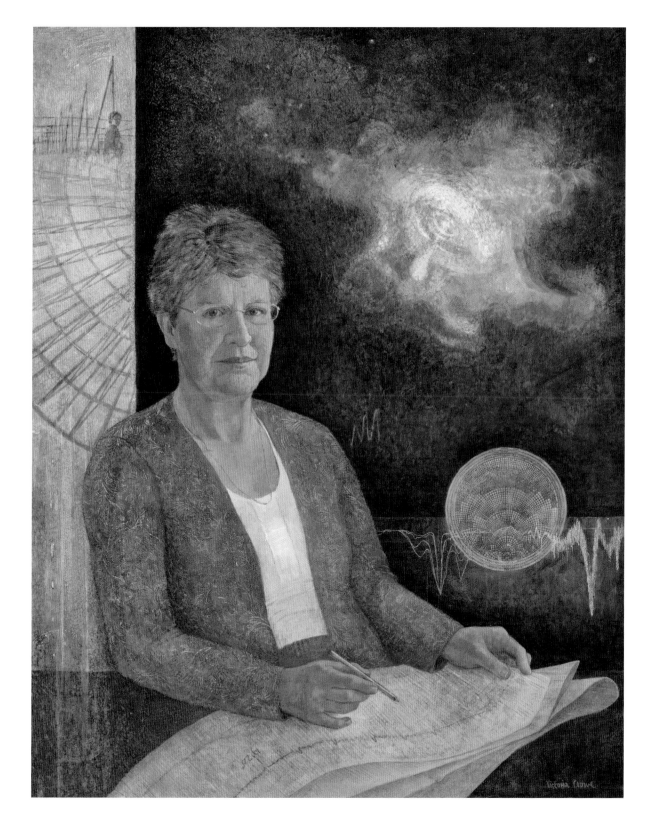

51 Timothy O'Shea

2017 · oil on linen, over two canvases · 140 × 280 cm
University of Edinburgh Art Collection

Before the sittings with Tim began, I wondered what on Earth we would talk about … he was the successful Principal of Edinburgh University and had been a computer scientist with an interest in robotics. However, he also had a fascinating background, with an Irish father and a Silesian mother, and was the first Roman Catholic Principal of Edinburgh University. An early meeting in December, as part of the portrait-making process, involved a car trip to the new veterinary school at Easter Bush Campus to deliver mince pies. He was enthusiastic about all the new building and development the University had made during his tenure, and we also visited the Informatics building. This gave me the first idea of how to deal with the computer science world I knew nothing about. Tim showed me the building and told me about the Valkyrie robot … unfortunately her/its room was locked on that visit, but it set me thinking about the juxtaposition of a human being and a robot. The architecture of the Informatics building became the background of the portrait. Internal glass divisions around the atrium allowed external and internal vistas, and I was able to use that dual function to reference the city outside. I included the McEwan Hall, the skyline of Edinburgh and Arthur's Seat, where Tim regularly walked, as well as drawing the interior. The windows and glass divisions of the study rooms were used by students and researchers to write on, providing layer upon layer of formulae and calculations, which together with reflections and architectural divisions made a complex but transparent screen containing many elements significant to Tim's period of office at the University.

The hidden presence of the huge robot, which had fascinated me on the first visit, made me want to go

and draw it. Valkyrie is a NASA-funded collaboration at the University of Edinburgh, the only one in Europe to be working on the development of a prototype robot to walk on Mars.

I wanted to juxtapose the figure with the robot to consider and question the relationship. Parts of our conversations during the sittings were around artificial intelligence and particularly the nature of consciousness and the work of Dan Dennett, an American philosopher and cognitive scientist whom Tim knows well. When I had been drawing the Valkyrie, I felt awed not by the sophisticated mechanics of robotics, but in comparison, by the elegance and simplicity of the human body. I thought of this contrast as a metaphor for our thoughts and conversations around the idea of consciousness. Early on in the development of the portrait, I realised that it needed to be enlarged over two panels and to have an additional human element, a reflected image of Tim facing the robot. The relationship and tension between the two human aspects, together with the transparent architectural divisions and views outside, gave a space in which memories, thoughts and possibilities could be contained.

PROFESSOR SIR TIMOTHY MICHAEL MARTIN
O'SHEA (B.1949)
Computer scientist and educator. Research Fellow in the Department of Artificial Intelligence at the University of Edinburgh, 1974–78. He later became Principal and Vice-Chancellor of the University of Edinburgh, 2002–17. In 2004 was elected Fellow of the Royal Society of Edinburgh, and was awarded an Honorary Doctorate by Heriot-Watt University in 2008.

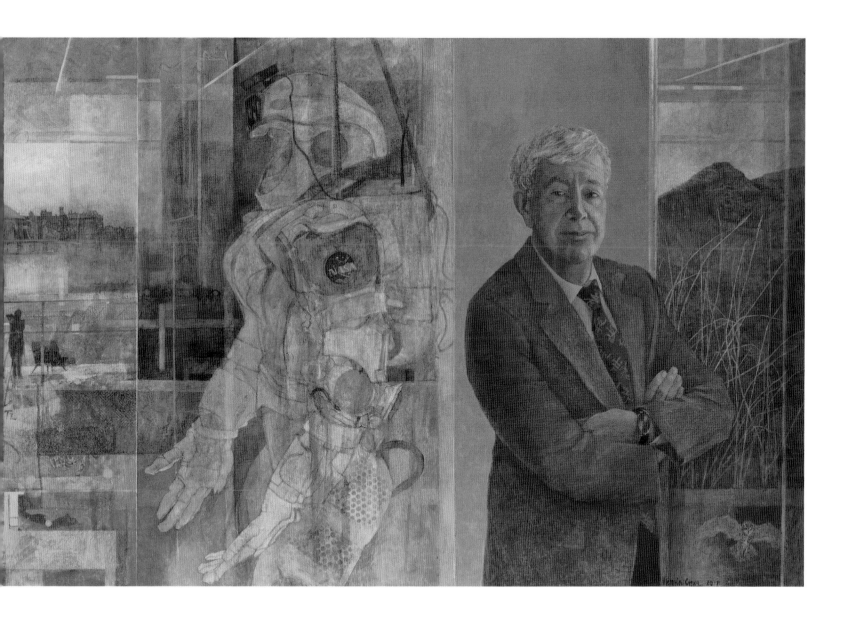

Victoria Crowe

OBE DHC FRSE MA(RCA) RSA RSW (B.1945)

Victoria Crowe studied in London, at Kingston School of Art from 1961 to 1965 and at the Royal College of Art from 1965 to 1968. For thirty years she worked as a part-time lecturer in the School of Drawing and Painting at Edinburgh College of Art, while developing her own artistic practice. Her first one-person exhibition, after leaving the Royal College of Art, was in London in 1969 and she has subsequently gone on to have over fifty solo shows.

She has exhibited nationally and internationally and undertaken many important portrait commissions.

In 2000, her exhibition *A Shepherd's Life*, consisting of work selected from the 1970s and 1980s, was one of the National Galleries of Scotland's Millennium exhibitions. It received great critical acclaim. The exhibition toured Scotland and was revived in 2009 for a three-month showing at the Fleming Collection, London. In 2016 a group of work by the artist was acquired by the National Galleries of Scotland.

Victoria is a member of the Royal Scottish Academy (RSA) and the Royal Scottish Society of Painters in Watercolours (RSW). She was awarded an OBE for Services to Art in 2004. From 2004 to 2007 she was Senior Visiting Scholar at St Catharine's College, Cambridge; the resulting work, *Plant Memory*, was exhibited at the RSA in 2007 and subsequently toured Scotland. In 2009 she received an Honorary Degree from the University of Aberdeen and in 2010 was elected a Fellow of the Royal Society of Edinburgh. She served as Deputy President of the RSA in 2013–15.

In 2013, Edinburgh's Dovecot Studios wove a large-scale tapestry of Victoria's celebrated painting *Large Tree Group*, 1975 (Scottish National Gallery of Modern Art). The tapestry was acquired for the National Museums of Scotland and became part of an international touring exhibition called *Follow the Thread*.

She was commissioned by the Worshipful Company of Leathersellers in 2014, to design a 40-metre tapestry for their new hall in the City of London; it took over three years to weave, and was installed in January 2017.

A collaboration with opera singer Matthew Rose and pianist Gary Matthewman on a production of Schubert's song-cycle *Winterreise*, for a series of performances at Snape Maltings in Suffolk and at London's Wigmore Hall in 2017, involved a 70-minute video projection of Victoria's winter paintings, creating a visual journey in parallel to the music.

Victoria Crowe is represented by The Scottish Gallery, Edinburgh and Browse & Darby, London.

www.victoriacrowe.com